D1634975

GOYA

The life and work of the artist illustrated with 80 colour plates

MARGHERITA ABBRUZZESE

THAMES AND HUDSON

Translated from the Italian by Caroline Beamish

This edition © 1967 Thames and Hudson, 30–34 Bloomsbury Street, London WC1
Copyright © 1967 by Sadea Editore, Firenze
Reprinted 1984

Printed in Italy

Life

On 30 March 1746, in Fuendetodos, a village in the Aragonese province of Saragossa, Francisco Goya was born, the son of humble parents. His father José, the son of a notary, worked as a gilder and his mother, Gracia Lucientes, owned a small piece of land in Fuendetodos; the boy's birth in the village was due to the fact that the family, who generally lived in Saragossa, had moved there temporarily for financial reasons. Goya's long, complicated life has been so embellished by legend over the years that even today not every detail of it is clear. I shall try however to single out the most important events, which help to throw a light on Goya's character, to illustrate his relationship with the world around him, and to describe the stages of his artistic development.

He was born into social and geographical surroundings which were common to a large part of Spain in the eighteenth century: parched and barren land, far away from the splendours of the court of the kings of Spain, yet a stinging reminder of their blindness and neglect; here contemplation of one's surroundings rarely evinces poetry: on the contrary, human contact is the only reality, and it can only stir up a passionate recognition of the human condition. In spite of the fluctuations of Goya's career as an artist and the very varied experiences he went through, there is a unifying element in his life and his work which can be traced back to his fundamentally Spanish nature; his temperament was typically Spanish and his life was unmistakeably that of a Spaniard.

In 1760, having spent the early years of his boyhood at Fuendetodos, Goya and his family moved to Saragossa and there for four years he went to school at the Escuela Pía del Padre Joaquín, a religious foundation. Then he took lessons in drawing and painting from José Luzán, a mediocre academic painter whose only achievement (even if it was unconscious) was that he acquainted his pupils with a variety of engravings, which he made them copy. At this

time Goya met two people who were to be of importance in his life: Martín Zapater, a faithful friend with whom he was to correspond for the rest of his life (leaving a precious source of information for his biographers), and Francisco Bayeu, a fellow pupil, older than he, his future brother-in-law and at different times his teacher, protector, colleague and bitterest foe. Zapater and Bayeu were both summoned by Mengs to Madrid in 1763, and Goya followed them shortly afterwards, attempting, without success that year, the examination to gain admission to the Academy of San Fernando; three years later he tried again and again was turned down. We do not know what works he sent in, but it is easy to imagine that the historical subjects set by the academy would not arouse much enthusiasm. And Goya's instinctive search for expression free from convention – which at this stage cannot have found a suitable vehicle in his style – would not have interested his academic judges. The artistic scene in Madrid at that time was extremely complex and confusing. Artists were divided into two camps: the court had until then welcomed with equal favour Italian painters such as Giaquinto and French painters such as Houasse, Ranc and Van Loo. In the second half of the century the old and the new styles were both represented by great painters who, from their opposite camps, founded the 'great tradition': in 1761 Mengs arrived and in 1762 Tiepolo. The heir to the baroque and the vanguard of neoclassicism worked side by side, and it was impossible for them to avoid the approbation, though for opposite reasons, of large numbers of artists and lovers of art. The uncertainty of the young Goya's style and his instinctive shunning of convention meant that he was unacceptable to either camp.

In about the year 1770 he was in Italy, probably in Rome; in 1771, though he had won only the second place in the competition for admission to the Accademia di Belle Arti in Parma, he is mentioned favourably in their chronicle. It is noted that he would have won first prize if he had stuck more closely to his subject and if he had applied his colours with more regard for naturalism. These are important records as they already show Goya as a rebel, though he was only a young unknown at the time.

In 1773 we know that Goya was in Madrid, where he married Josefa Bayeu, the sister of the painter who had introduced him into Madrid society. His first important chance was a commission for a series of cartoons for tapestries, which Mengs (possibly advised by Bayeu, who had acquired a certain reputation and had become part of a group of young academic painters, which included his brothers) commissioned for the Royal Tapestry Factory at Santa Barbara. It was an important opportunity because it meant that Goya was admitted to court circles; in addition this kind of work allowed him great freedom in his choice of subject matter and of technique. Perhaps most important of all, the sketchy nature of the cartoon medium spared Goya the necessity of 'finishing' his work. His style was slow to mature; until now he had displayed a dextrous hand but had shown no signs of genius.

The work that he had been given presented to a certain extent the danger of falling into traditional genre painting, in the French pastoral or the Dutch *naïf* style, which had been current for so long in the history of tapestry. However Charles III, possibly the most liberal ruler of Goya's lifetime, proposed a change of subject, perhaps for nationalistic reasons. Tapestries were now to portray scenes from Spanish life. After a first uninteresting series Goya, thanks to Charles III, found exactly the right note and exploited it, with growing maturity and mastery of his materials, from 1776-7 on: his *Picnic on the banks of the Manzanares, Dancing by the River Manzanares, The Sunshade* (pls 2-3), *Fair in Madrid*, and *The Crockery Seller* (pls 4-5), and other cartoons mark the first appearance in Goya's work of that note which so directly reproduces the tenor of Spanish life; through this work he continued to deepen his observation of life in general, of mankind and its condition. Sánchez Cantón has stressed the influence of Houasse on Goya, or rather he has pointed out that Goya had evidently looked with a sympathetic eye at Houasse's genre paintings and his religious scenes; he must have admired their spontaneity. From now on Goya's sucess grew and grew; not only did he make his mark both at court and on the general public, but he clarified his position and his future plans in his own

mind, recognizing the impossibility of submitting to the academic yoke. After the death of Mengs, whose fame and whose austerity had stood in the way, Goya took up a lonely position in opposition to the dreary mediocrity of the academics, against whom it was impossible not to react. There followed a succession of cartoons (their order is listed by Valentín de Sambricio in his careful study), and their style and the interpretation of the subject matter grew increasingly mature.

It must have been the subjects of Goya's paintings rather than the modernistic way in which they were treated which won him wide public acclaim; in 1780 a *Crucifixion* (*pl 12*) was accepted by the Academy and it clearly satisfied their taste for sentiment and strongly modelled figures; for us today it provides a valuable key to the character of Goya as a man and as an artist. His character may seem weak and open to compromise in dealings with other people, through fear of failure or poverty; nevertheless he had the gift of compassion, which he translated instinctively into pictorial terms (see for example his free treatment of Christ's face in the *Crucifixion*), and this saved him from aesthetic compromise. His painting is an expression of moral feelings and at times is startlingly direct and sincere. One realises how frequently the hand and mind of a man get the better of his will. This may explain how even if one had not read works which analyse the painting in modern terms, it would still offer the possibility of various interpretations; so much so that Goya's contemporaries completely failed to see how really controversial it was, so smitten were they by its pictorial qualities.

Goya's contact with the court had by now introduced him to the work of Velázquez, several of whose paintings he made into engravings, in a series dated 1777-8 which he sent to Zapater. His acquaintance with Velázquez was fruitful (even though these engravings were not a success) because Velázquez' realism struck a chord in Goya's mind, and reaffirmed his belief in a personal style.

When, from October 1780 to June 1781, he was commissioned to make sketches for the painting of a dome in the cathedral of El Pilar in Saragossa, dedicated to *The*

Virgin, Queen of Martyrs (pls 13-15), a battle over fundamental ideas broke out between him and his brother-in-law Francisco Bayeu, who was the official director of the work in the cathedral. Goya, though consenting ungraciously to modify parts of the sketches, would not completely surrender his liberty in the execution of the frescoes; he refused to give up his expressively distorted figures, his spacious layout, or his close attention to detail, even though the ceiling was planned in the grand manner which was then traditional. His ideas were in complete opposition to the aesthetics of Mengs, which were immutable laws to Bayeu. Goya constantly found himself in disagreement with official circles, and always for the same reason: on one hand he wanted to please contemporary taste in his composition, his themes and in the general plan of his works; on the other hand his personality seemed to burst out irrepressibly with results that were never the same twice, and which were by no means always happy. However, his painting *St Bernard preaching to Alphonso V of Aragon,* commissioned for the church of San Francisco el Grande in Madrid and inaugurated in 1784, was a triumphant success. This period of uncertainty, when Goya's popularity moved in sudden spurts, has only been partly documented as far as the paintings are concerned.

It is reasonable to suppose that Goya was getting greater satisfaction from painting the portraits which he had for some time gratefully undertaken (*Portrait of Don Pedro Alcantara de Zuñigo,* 1774, *Portrait of Cornelius van der Goten,* 1781, and *Portrait of the Count of Floridablanca,* 1738 (*pls 16-17*). His portrait-painting activity was further increased by commissions for paintings of the royal family, in particular the Infante Don Luís. Portrait painting admits the same stylistic alternatives as does religious painting, but gives the painter more scope for psychological investigation.

The letters written to Zapater during this period show a period of alternating gloom and serenity; they also bear witness to Goya's long and difficult consolidation of his aesthetic ideas. Further official successes were not slow to arrive; Goya was elected Assistant Director of the depart-

ment of painting of the Academy of San Fernando in 1785 and was named Official Painter to the Royal Family in 1786. At the time he won commissions from some of the greatest Spanish families, the Medinaceli, the Osuña (portraits, two paintings of the life of St Francis Borgia for the family chapel in Valencia Cathedral and seven paintings for the Alameda), and from the Banco de San Carlos. He had begun doing cartoons for tapestries, for which he was famous, again in 1786. The subjects are various; the execution ranges from mawkishness to a disconcerting realism; however it would be difficult to fit any of them into the traditional picture of genre painting. They belong to a completely new genre. Goya's treatment of his subjects, sometimes touching on social satire, is something quite new. Examples of this are the *Wounded Mason* (*pl 26*), and the portrait of contemporary manners *The Field of San Isidro* (*pls 30-1*). Other paintings of this period include religious pictures and portraits: three canvases for Santa Ana in Valladolid, the paintings mentioned above for the cathedral in Valencia, and various superb portraits such as the child portrait of Manuel Osorio de Zuñiga.

After a setback at the Academy in 1788, when Goya failed to be elected Director through malice and rivalry among the members, he was awarded the position of Court Painter following the accession of Charles IV to the throne in 1789. This title set the official seal on Goya's position as portrait painter: it gave even more incentive to work at court and to know how to be accepted there without actually becoming a courtier. He wrote at this time that it was essential for his character that he learn to control himself and ' to adhere to my principles, maintaining that dignity that every person should maintain'. He continued his work for the Tapestry Factory, although more slowly: *Summer* (*pls 21-3*), dates from 1786, *Blindman's Buff* from 1789 and *The Manikin* (*pl 32*) from 1791.

In 1791 his work for the Santa Barbara factory ceased, but subjects like the ones in the cartoons continued to interest him; he also used the same subjects in paintings (he had done this earlier with one or two of his compositions). The series inspired by the bull ring dates from this time.

Since 1786 the relationship between Goya and the Alba family had become increasingly close, and Goya had been their guest on several occasions. His friendship with the Duchess of Alba belongs however to a later date, between 1795 and 1797. In 1790 we know that he was in Valencia, where he was elected to the Academy of San Carlo, then in Saragossa where he painted the portrait of Martín Zapater. In 1792 he was presumably in Cádiz where he painted the portrait of Sebastián Martínez and three pictures for the Oratory of the Sacred Well. It was while he was in Cádiz, staying with Martínez, that he contracted the illness which, by leaving him deaf, was to have such a vital effect on his life and on his painting. Dr Blanco y Soler has made an analysis of Goya's illness, based on documentary evidence and in particular on letters from Martínez to Zapater and Arascot, and from Goya himself, and he maintains that he was suffering from a condition of the middle ear (neuro-labyrinthitis). Whatever it was, it is true to say that after his recovery, which was never complete, Goya revealed such a sure mastery of his materials and expression as to amount virtually to a complete metamorphosis, or at any rate to a substantial enrichment. The difficulty of communicating with other people, and the isolation which a physical disability of that nature is bound to cause, must have made Goya more introspective; it also must have brought him face to face with reality without any of the usual intermediaries or shields. He had already acknowledged the possibility of experimenting with reality to bring out its widest and most divergent meanings. Now, into his painted visions, where every detail is mercilessly depicted, there creeps an all-pervading, quasi-religious satirical intensity.

After his convalescence Goya returned to Madrid and there he painted eleven pictures for the Academy; the identification of these is uncertain owing to the extreme difficulty of dating works on stylistic grounds alone. In 1794 he wrote to Bernardo de Iriarte: ' In order to occupy my mind, numbed by meditation on my own ills, and to repay the heavy expenses incurred during my illness, I have begun to paint a series of small pictures in which I have succeeded in including observations which cannot generally be found

in commissioned works; as a rule in commissioned paintings caprice and imagination cannot be developed'. Modern critics have tended to assign to this period works such as *Bandit Attacking a Woman, The Shipwreck, The Fire*, all of which are very small; other works usually assigned to this period include scenes of violence and scenes from low life, and also surrealistic paintings such as *The Devil's Lamp, The Spell* (*pls 36-7*), and the *Flight of Owls,* all of which were bought by the Osuña family in 1798 but were probably painted much early. The same critics regard the following pictures as belonging to a somewhat later date: *The Procession of Flagellants* (*pl 40*), the *Bull Ring* (*pls 46-7*), *Court of the Inquisition* (*pls 41-3*), *The Burial of the Sardine* (*pls 38-9*) and also *The Madhouse* (*pls 44-5*). Earlier critics such as Sánchez Cantón regarded this as the first group of paintings done by Goya after his illness. At all events the absence of documentary records, and the difficulty of organizing Goya's works into distinct phases of style, make the dating of all these paintings very arbitrary. However they cannot belong much after 1800, as the years after the turn of the century are fairly adequately documented, and none of these works is mentioned.

Goya continued to be employed as a portrait painter, and in 1793 finished the portrait of Caveda; in 1794 he painted the actress La Tirana (*pl 53*), General Ricardos, Ramón Posada y Soto and others; in 1795 the Marquesa di Villafranca, his brother-in-law Bayeu (who died during the same year and left the post of Director of the Paintings of the Academy free for Goya), and the Duke and Duchess of Alba. The Duchess of Alba was to become an important figure in Goya's emotional life, whether the colourful stories of their passion for one another are to be believed or not; a close relationship certainly existed, even if it went no further than deep friendship and mutual esteem. Important among Goya's works at this period are the frescoes in San Antón de la Florida, 1798, and the series of *Caprichos*, 1799, which in their different ways both reflect typical facets of Goya's character. Goya was now appointed First Court Painter, and started work on a marvellous series of single and group portraits of the royal family and of many

other court personalities. These portraits include the picture of Maria Luisa, painted at Granija, and the picture of Charles IV, painted in 1799; also the portrait of the liberal Mariano Luiz de Urquijo. In 1800 one of the most famous group portraits was painted, *The Family of Charles IV*, at Aranjuez: this is a vision of the Spanish monarchy and of the country of Spain seen through the eyes of an ordinary citizen. From now on right through the first ten years of the new century, Goya's chief activity was painting official portraits: his job was to idealize his sitters but, like Velázquez, he preferred to concentrate on their psychological qualities. He did not give up his pictures of popular life in the meantime, and these are undoubtedly his more authentic expressions. Presumably in about 1806-7 he painted a series of six small paintings of the *Capture of the Bandit Maragato*; these are new departures, in their liveliness of action and historical feeling.

Realism, not in its accepted sense of naturalistic representation but as a form of the artist's awareness of the function of his work, came into existence in the troubled Europe of the early nineteenth century. The realism of a Courbet or a Daumier was anticipated by nearly a century by the lonely figure of Goya, whose work was largely ignored or misunderstood. As the political storms raged overhead – the Napoleonic occupation and the popular reaction against it, monarchs rising and falling, liberals pressing forward – Goya had more cause than ever to take stock of his aesthetic position. Once again his instincts and his natural unblinkered innocence prevailed over the careful behaviour of the official artist. If we examine Goya's life at this period carefully, his position does not always stand out very clearly; he remained involved with the court and the Academy because of his obligations to them, but his painting became more and more openly denunciatory and polemical. It is interesting to note how closely his work mirrors events: not only does he portray events, but the different quality of what he produced is in a way an interpretation of the events themselves. In 1808 Napoleon was threatening invasion. In Aranjuez the people, putting their hopes in liberation by the French, revolted against the king and forced

his abdication and the succession of Ferdinand VII. This inept monarch, whom Napoleon was keen to be rid of, abandoned Madrid and allowed Murat to enter the city unopposed. On 2 May the people of Madrid took up arms against the French and attacked a detachment of Mamelukes. Reprisals were violent and there was shooting throughout the night of 3 May; in the morning Spain was in the throes of a war which was to last for four years, under the short-lived reign of Joseph Bonaparte. Goya's friends, many of whom were 'Frenchified' intellectuals (*afrancesados*), had welcomed the French anti-absolutism and the Constitution. Goya nevertheless retained his office as official painter to the court and, with the disconcerting directness typical of him, painted a portrait of Ferdinand VII on horseback; this official consecration of yet another useless monarch stands as a monument to their by now completely anachronistic position. A little later he produced a series of etchings, the *Disasters of War*; here the subject and its treatment are absolutely up to the minute. With confident handling of his medium Goya dealt with the subject of suffering caused by violence and brutality. The dating of these etchings is uncertain, some people naming 1808 as the date when they were started, others, such as Carderera, putting their completion as late as 1820.

In the autumn of 1808 Goya was in Saragossa, observing and recording the disasters caused by war in his own town. His pictures were discovered by French soldiers in the house of General Palafox and were all destroyed. On his return to Madrid he continued to work hard at his portraits, and maintained his position as Royal Painter to King Joseph. Against his will he was entrusted with the selection of fifty Spanish works of art to send to France; he also had to attend a special sitting of the Academy to welcome a protégé of Joseph Bonaparte, and he was invested with the Order of Spain. The years 1812-14 are not very fully documented; certain events are known, and on the basis of these and the few precise documents there are some phases of activity that can be reconstructed. In 1812 his wife Josefa Bayeu died, and her death led to an inventory of property being compiled which is a precious source of information

as seventy-three works by Goya appear in it, briefly described, and also paintings by other artists whom he admired. Thanks to this inventory the year 1812 constitutes a *terminus ante quem* for the dating of the paintings on the list, though these are not always easily identifiable; nevertheless stylistic comparisons make it possible to date them with moderate certainty. This means that the works dating from about 1812 are *The Water Seller, Two Drinkers, The Knife Grinder, Colossus (pl 63), The City on a Rock, The Balloon, Soldiers shooting their companions*, several *Majas* and the two paintings now in Lille, *Majas Walking (pl 61)* and *The Old Women*. Two paintings done in 1814 are landmarks in the history of modern painting: *2 May 1808 (pls 64-5)* and *3 May 1808 (pls 66-7)*. Goya was officially commissioned to paint these in honour of the Spanish resistance. No paintings could be further removed from the traditional presentations of history or from the usual academic grand manner of these paintings; yet these are more closely connected with the episodes they portray than any others, before or since. The return of Ferdinand VII brought with it the persecution of liberals, and Goya himself was threatened, even though he continued with his portraits of the king and his courtiers

It was a long time since Goya had undertaken any religious subjects, and he had only ever done it sporadically. However in 1812 he painted an *Assumption of the Virgin* for the parish church of Chinchón, and in the following years he greatly increased his activity in this field. In 1819 he painted the *Last Communion of St Joseph Calasanzio (pl 68)* and the *Agony in the Garden (pl 69)*, two works whose style and freedom of technique bring them right to the threshold of modern art. Goya's work as a draughtsman and engraver was of key importance to his modernism. The *Caprichos* and the *Disasters of War* had both been extraordinarily inventive, combining liberty of structure with liberty of expression. The series known as *Tauromaquia,* and also the *Proverbs* (both dating from about 1819), present an extraordinarily original composition.

In 1819 Goya bought himself a country house on the banks of the Manzanares, traditionally known as ' La Quinta

del Sordo ', the ' deaf man's house ' (a study by the Marqués del Saltillo shows that the house was so named before Goya bought it). During the years 1820-2, having recovered from another severe illness, Goya devoted his time to the decoration of his house, and the ' black paintings ' were born. These paintings in a way represent the climax of Goya's love affair with the rough sketch and its enormous vitality; here his subjects are simplified as far as possible and reproduced on an enormous scale, with rapid and pregnant brushstrokes. Each stroke in Goya's shorthand interpretation of a colossal vision, in which monsters are intermingled with everyday things, seems to be on a human, familiar scale; yet the power of the vision is expressed in each one.

The huge compositions from the Quinta del Sordo, left untitled by Goya, were fourteen in number (all are now in the Prado), and were painted in oils directly on to the plastered wall. They decorated an enormous living room on the ground floor. By the door is a *Manola* and an old priest with a devil shrieking in his ear. On either side are a *Scene at the Hermitage of San Isidro* and a *Witches' Sabbath* (pls 70, 72). Upstairs in the study is a *Dog buried in Sand, Two Old Women Eating Soup* (pl 76-7) and *The Reader*. On either side are *Destiny, The Brawl, The Pilgrimage of San Isidro* (pls 71, 73) and *The Fantastic Vision* (pl 75).

It is only by good fortune that these paintings still exist today. They were preserved thanks to the Baron d'Erlanger, who bought the house later. He had them removed from the walls and framed in 1873. They were exhibited in Paris at the Exposition Universale in 1878, but nobody took much notice of them; only later were they acquired by the Prado. Goya's official position, which he still maintained, and his desire to experiment, were making life increasingly difficult for him. He had already had some trouble with the Inquisition over the two *Majas*. With the restoration of the monarchy and the repressions that followed it Goya, for fear that his house would be confiscated, handed over La Quinta del Sordo to his nephew Mariano in 1823. In 1824 he went into hiding in the house of Don José de Duaso y Latre and then requested and obtained permission to leave

Spain for a thermal cure at Plombières; this constituted in fact a voluntary exile. He went at once to stay with Moratín, his old friend who had fled to Bordeaux, and later stayed for a long time in Paris, taking Joaquín Maria Ferrer and his wife with him. He returned to Bordeaux and decided to stay there permanently with Leocadia Weiss, his inseparable companion in the last years of his life. The court gave him permission to prolong his stay. Much happier, and almost a new man in his new life, Goya began to paint hard again. He painted the *Portrait of Moratín* (*pl 51*) and took up painting miniatures on ivory. Though he was warmly welcomed when he did return to Madrid in 1826, he requested to be freed from all his official responsibilities, and in the summer he returned to Bordeaux, where he painted a portrait of his nephew Mariano, some religious pictures and the well known *Milkmaid of Bordeaux* (*pl 79*), an example of his last, almost impressionistic style. In 1828 he started the portrait of José Pío de Molina (which remained unfinished). He died on 11 April 1828 in Bordeaux.

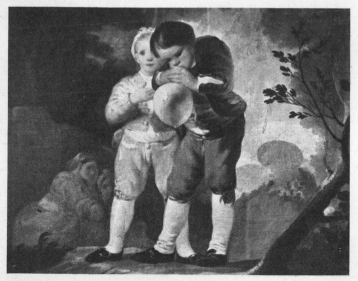

Boys blowing up a bladder (see note on p. 32)

Works

From the preceding notes on the life of Goya the dominant aspects of his personality, and the apparent dichotomy between the painter and the man, will have emerged. This dichotomy in his nature could serve as a starting point for an analysis of his work. The Goya presented to us by tradition is wrapped in a thick halo of legend, and is credited with a vast body of paintings, many of which have never been proved to be his. Only during this century, and especially in recent years has his work had a thorough re-examination, through close analysis of the documents that exist and detailed study of the style and content of each painting or engraving.

The disconcerting aspects of Goya's life are, first, his official position as a painter to the court, combined with his open censure of all that the king and the court stood for; secondly, the modernity of his work – he gives the same treatment in terms of thought and expression to an enormous variety of subjects; third, his failure to align himself definitely with any political party, and lastly his failure to conform to any clear ideology. All these are useful pointers to social and political conditions of the day, and can teach us a lesson in history. To the Academy, Goya represented anti-art, and continued to do so even when his paintings were at the height of their popularity: they were so widely admired because they were not understood.

This Goya, the man who stood for anti-art and anti-culture, is a key figure in the civilization of today; in the most revolutionary way possible he bridged the gap between the old and the new, opening the gates to the modern conception of art.

From this mass of contradictions, real or imaginary, Goya emerges. His character is a little timid to start with, but nevertheless able to withstand poverty and hardship with admirable tenacity and fortitude. His ambition is straightforward, based on a desire to work and to make a name for himself; through his painting he strives after self-

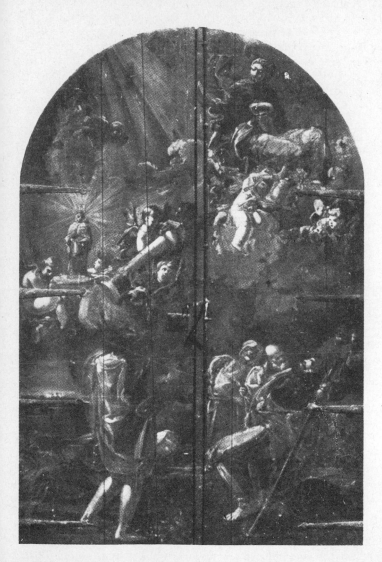

The Virgin of Pilar, reliquary (see note on p. 32)

realization and moral perfection. Yet he is not always so fully conscious of what he is after; if we remember the long period he spent working for the Royal Tapestry Factory, and the various religious commissions he undertook early on in his career, it is plain that he was willing to accept jobs that his instinct must have rejected out of hand. His subconscious is at work even here, lending life and truth and a breath of non-conformity to the most inhibiting holy picture or genre painting.

' Each of us is given but a few days on this earth, and each should spend his days as he wishes. ' These words sound like the maxim of a man of pleasure; Goya's confession to Zapater was a typical example of the way in which he could dismiss everything that was not to his liking. But how can this be reconciled with Goya's behaviour in everyday life, and particularly after he had become a success? How was it possible to live amongst a group of people, accepting the honours they chose to bestow upon him and their commissions, soliciting their favour and their money, and all the while feeling at loggerheads with them and attacking them with ruthless cruelty? As a rule a courtier will flatter and humour his overlord, even at the expense of compromising himself. This certainly was not how Goya behaved. The answer must be that only the total blindness on the part of the members of the court of Spain in the eighteenth century could have permitted them to tolerate Goya; they cannot possibly have perceived the significance of his paintings and must have been carried away by his able draftsmanship. Their blindness and total want of perception must be attributable to their unwavering conviction of being right, and to their inability to notice anything beyond themselves (paragons, in their own opinion, of truth, justice, and beauty). Everyone who was not like them belonged to the poor and needy class, portrayed by Goya as repulsive, deformed and absolutely unacceptable. Sympathy for the poor, which Goya's truthful portrayal was calculated to evoke, never entered the heads of members of that class. So without discomfiting them at all Goya painted in the way he thought right, and their want of perception allowed him to go on doing so. The milieu in which he lived provided

him with an unending supply of models, and gave him an opportunity to experience the sufferings and the aggressions of human beings. Man is the constant subject of Goya's painting. In his portraits as well as in his genre paintings and his religious pictures, the presence of man is always the excuse for a momentary pause for reflection on the human condition. Human life represents truth to him, and is his most enduring inspiration. His greatest problem, which he solves by instinct, is how to tackle this truth in exactly the opposite way from the idealized way in which it would have been tackled by academic painters.

It is certainly possible to see a steady stylistic development in Goya's work, but it is hard to say whether it is as a man that Goya matures or as a painter. From the start Goya had regarded technique as something inextricably bound to ideas and inspiration, and which could at no time become an impediment to his expression. It is more difficult to discuss maturity of inspiration: it is true that between his early days and his old age the subjects of his paintings changed; he grew more and more introspective and increasingly prone to exacerbate reality until it almost entered the realm of fantasy – in fact he continued to give increasing depth to his vision of reality, adapting his technique to suit every development. Notwithstanding, the central motif of his work was always to be reality, life in the raw. Goya's realism is a kind of allegory of human life, with each type and character represented; his documentation of humanity, begun as ephemeral satire, ended as a generalization on the whole of mankind. This was because he did not interest himself in appearances, in fact he became increasingly prone to do away with the traditional form; it was cause and effect that interested him, and the drama that lies behind the scenes of life. He could breathe life into a courtier, an actor, a manual labourer, an object, a landscape, children at play or a monster: each was an actor playing a central role in the game of truth that is Goya's painting.

It follows from this that the unity of Goya's message lies in his constancy to reality and truth, and that this explains the huge diversity of his subjects, and also the coexistence of various types of work at one time during the different

phases of his life. There remains the difficulty of classifying and giving a date to such a huge number of paintings. Less problematic perhaps to us nowadays is the task of analysing and interpreting each painting.

Another element in Goya's character which I think it is useful to bear in mind when looking for a clue to the understanding of his work is his typically Spanish temperament, which is certainly a factor in his passion for realism. Velázquez, Murillo and El Greco spring to mind, but we should also consider the whole Spanish artistic tradition, including the Middle Ages and the early Renaissance, in which the figurative arts and literature followed almost identical courses. In literature, from *Lazarillo de Tormes* to Cervantes, every exponent of the Spanish soul has drawn his inspiration from the inexorability of Nature, from social conditions, from ceaseless political oppression and the whole drama of absolutism and revolt. These are the eternal themes of Spanish art. Spain is the country of extremes: boundless wealth and brutalizing poverty, fatalistic resignation and the bloodiest rebellions. Thus it was possible for total conformity of expression to be the thing at one minute, rebellion in the name of truth at the next; Velázquez' dwarfs, Goya's monsters, Picasso's *Guernica,* each of these says the same thing in the same terms, the language of protest. The truth must be seen and must be shown to others, including those who have no wish to see it. And because the blind in spirit stay their eyes on the outward aspects of things, then these outward aspects must be twisted and deformed until they cry out what they are trying to say.

Goya speaks of having had ' three masters, Velázquez, Rembrandt and Nature '; by master he means example, and not model to be copied. Certainly some of his broad compositions, certain instances of his use of light and shade and some naturalistic details could remind us in turn of Velázquez, of Rembrandt, of Nature. But his dialogue with his masters goes deeper than this: his careful selection (free of imposed plan, like everything else with Goya) shows that what he gleaned from the works of Rembrandt or Velázquez was not so much the obvious tricks of style as a moral and religious lesson on the subject of mankind. From

Nature his mind and soul learned that life is constantly changing and expending itself, being transformed in the most various ways, all of them true; he learnt more than the mind alone is capable of grasping, to use Baudelaire's words, and so the natural world and the world of fantasy became interchangeable in his mind. The objects we see through other objects are real, and the objects that stir our imagination are real as well.

Now we come to an examination of the personalities of those who were, or were reputed to be, Goya's masters during his lifetime. It should be established at once that although Goya knew very early that he wanted to be a painter, he did not really establish a personal style until relatively late in life. His studies with Luzán did nothing to stimulate him; his years in Saragossa were no more than a slight introduction to his profession. His acquaintance with the late flowerings of the baroque style, of which Spain was full, must have inspired him much more than the early examples of neoclassicism; baroque art gave so much more liberty to form and composition. And when Tiepolo arrived in Madrid and gave full rein to the imagination in a heady combination of realism and dramatic flair, Goya must have fallen wholeheartedly for the baroque; it coincided so completely with his ideas of imagination and the freedom of the spirit. The neoclassicist Mengs, on the other hand, temperamentally as well as artistically his antithesis, perhaps taught him something of carefulness, consideration and order. Mengs and Goya were linked by a common seriousness of purpose and faith in the usefulness of painting.

Goya's development began very slowly and his style shifted uncertainly until 1776. This was an eclectic period during which he assimilated facts of all kinds, absorbing them to reproduce them later when they had become part of him. His instinctive draughtsmanship and the directness of his approach always led him to the honest solution of the relationship between himself and his subject, and this saved him from sterile copying and dull academicism. In his youthful works, painted between about 1771 and 1780, we can catch a variety of echoes, from Luca Giordano to Giaquinto, Vouet and Maratta, and from the French painters at the

Spanish court to certain English paintings. Some of these painters he knew only through engravings, others at first hand, especially after his visit to Rome in 1771 and his subsequent introduction to the court. His long acquaintance with the works of his friend, Francisco Bayeu, later his brother-in-law, had conditioned him to a fair degree of conformity. Nevertheless in his early works (the decoration of a reliquary in Fuendetodos, about 1763, a *Holy Family,* about 1771, the earlier decorations in the Cathedral of El Pilar, Saragossa, murals in oils in the chapel of the So-bradiel Palace, also in Saragossa, in about 1771-2, and murals, also in oils, in the Charterhouse of the Aula Dei), he displays an agility in composition and a freedom of technique which would be unthinkable in Bayeu. Goya's capacity to re-fashion or modify at will any traditional technique sets him apart from his academic contemporaries, and carries him forward to the discovery of a direct and unadorned style, even while his compositions still adhere to the monumental and dignified models of his forebears.

Already in these early works one can see through to the sketch on which the painting is built up, and see how the finished work and the earliest plan of its layout are conceived in virtually the same way; Goya's sketches are works in their own right declaring, with great economy and concentration, the meaning of the final work. It is not uncommon to find that one of Goya's sketches in rough is superior to the finished picture, not because (as would be the case with most painters) in the sketch he dashes down his inspiration when it is still fresh, but because often they seem more finished than does the finished work, and not only in terms of expressiveness. In fact the technique used by Goya in his sketches is not very different from the technique in his final drafts, but the repetition of a picture on a much larger scale, besides forfeiting some of its freshness, does not improve it generally. A fast, free brushstroke with thick paint, using diffusion of the colour to give the illusion of light and shade, suggesting lines rather than firmly stating them – in a sketch understatement lends enormous vigour· but enlarge it, add to it and the vigour is lost.

Goya's cartoons do not fit at all into the traditional type of simplified picture for tapestry weaving, but for this very reason they are much richer and more individual as paintings. Their unsuitability for their ostensible purpose is confirmed by the remonstrances of the weavers, who found it almost impossible to follow the patterns, so varied and complex was their composition. Goya's work for the Factory at Santa Barbara falls into three periods: 1775-80, 1786-8, and 1791-2, and each of these periods marks distinct stages in the progress of his approach to realism. The backgrounds of these tapestries (except a few, including *The Washerwomen*) are much simplified, like theatrical backcloths, and this does not detract at all from the realism of the main subject – in fact it almost has the effect of projecting the central figures towards the spectator. The cartoons for the Royal Factory are linked stylistically with the decorations Goya did for the Alameda of the Osuña family, such as the *Tree of Cockayne* (*pl 27*), *The Swing* (*pl 28*) etc, with the bullfighting scenes *Catching the Bull*, *Death of a Picador* and works such as *The Water Seller* and *The Knife Grinder*. These works, painted at different periods, share a common style which reflects the influence of earlier painters, from Chardin to Fragonard and Watteau: Goya's sensual treatment of single objects and small still-life groups stems from Chardin, the freedom of his brushstrokes from Fragonard and his eighteenth-century gallantry from Watteau. But he goes further than these painters: he never uses the presence of crowds of figures as an excuse for lack of depth of feeling; his keen eye for detail pounces on the amusing episode, the glance exchanged – everything is there, faithfully recorded, but never recorded merely for the sake of factual accuracy. Here Goya departs from the French tradition and from that of seventeenth-century Holland. He stands apart, too, from the *bamboccianti*, whose taste and methods of expression never rose above an amused or amusing look at poverty or toil. They found sources for their realism in a society which never would, nor ever could have taken part in an uprising. Their people are alive, human and at times even likeable, but they are waiting to be animated like figures in a cartoon, to amuse the spectators; human pity for

their tiredness, their poverty and pain is nowhere to be found. But Goya, himself a son of the oppressed masses, lived at a time when the French Revolution was coming to the boil. His scenes from life include members of the ruling class as well as the poor; they can be looked down upon too, and are liable to be amusing as well as amused. I noted earlier that at any rate in the early part of his life, there was neither system nor design in Goya's social criticism; nevertheless nothing escapes his eye, and he denounces even when he perhaps has no intention of doing so. So his first genre paintings (I use the term for convenience, but I should insist on its irrelevance for Goya) incorporate realistic elements and veiled protest, but are never dramatized.

After his illness, in the pictures he painted, in his own words, to alleviate his suffering, we discover the true nature of his anecdotal painting. Deaf, lonely and depressed, his total concentration on his vision of the world is no longer distracted. In painting he follows every whim of his imagination, using no preconceived plan and none of the conventional disguises for reality. Goya's first works on these lines were varied in subject, including for instance scenes of brigandage (*Bandits Attacking a Carriage, The Shipwreck*), in which Goya bathes everything in brilliant light, heightening the dramatic impact of the scene. The pictures of hallucinations also belong to this group; in these the fantastic, the real and the grotesque are inextricably confused; these were the pictures acquired by the Duke of Osuña in 1798, though they were probably painted earlier than that. They include scenes of black magic such as *The Devil's Lamp, Flight of Owls, The Spell* (*pls 36-7*). His choice of subjects widened afterwards and he painted a carnival scene, *The Burial of the Sardine* (*pls 38-9*), *Procession of Flagellants* (*pl 49*), *Court of the Inquisition* (*pls 41-3*) and *The Madhouse* (*pls 44-5*). Recent criticism has attributed to these a later date on stylistic grounds (about 1800), but nevertheless they represent the final expression of Goya's realism in its first phase. Realism emerges from many tiny details, such as the old woman in *The Crockery Seller* (*pls 4-5*) or the *Blind Guitarist* (*pls 9-11*), as well as in the choice of certain subjects, for instance *The Wounded Mason*

24

(*pl 26*) and the tragic *Winter* (*pls 18-19*); it also stands out in the pictures where shapes and scenes are distorted, such as the *Witches' Sabbath* (*pls. 34-5*) and finally of course in the violent *Court of the Inquisition* (*pls 41-3*) where only the figure of the accused man is at all lifelike, the rest of the crowd being presented as grotesque, the terrifying *Madhouse* (*pls 44-5*), and the *Fever Hospital*.

The consciousness of reality, and not realism in the sense of naturalistic representation of objects, is the basis of Goya's idea of realism. '*El sueño de la razón produce monstruos*', says the caption to one of the *Caprichos*; 'The dream of reason brings forth monsters'; on the strength of this I should like to put forward two interpretations; both seem to fit the character of Goya. When a man's reason lies dormant, and is no longer in control, real objects and people become distorted into monsters which are the products of the degeneration of man's animal nature. Or when a man's reason is caught up in dreams, escaping from its normal objective recognition of reality, his mind is freed to chase the ghosts that haunt him – ghosts produced by those objects in real life which disturb him more than anything else. So in Goya's visions the monsters take shape and become deformed brigands, decking out the *Majas* in order to put them on the streets; old, old women, whose faces and figures plainly demonstrate what lies in wait for young people, symbolize all the vices that beset the human race – deceit, flattery, corruption, lack of principle, egoism; bogus clerics, deceiving the crowd with their play-acting; grotesque masks in which everyone may find something of himself. Perhaps these are myths, but myths based on life's truths.

The age of Enlightenment, spent in the least enlightened country in Europe, made him discover that man is always the central character in a drama, whether conqueror or victim; abstract ideas cannot convey sense, whether the neo-classical conception of beauty or the goddess Reason of the Enlightenment. Goya clung to his view of man through-out, even in the portraits which won him fame and recognition. Basically Goya's ideas about portrait painting and about genre painting were very much alike: after all in the genre painting we find the odd portrait, and in the

portraits the detailed painting of scenery, the desire to pinpoint a moment in time rather than merely to commemorate the sitter. When the subject of a portrait is caught motionless on the canvas, he is nearly always surrounded by life (a birdcage, cats, or the magpie in the portrait of little Manuel Osorio). Or he himself is alive, captured in the middle of a movement or a fleeting facial expression, as for instance in the portrait of José Pío de Molina, painted only just before Goya's death, which has a directness and vitality absolutely unprecedented in the history of the portrait. The two *Majas* (*pls 58-60*) are undoubtedly portraits, but at the same time they are modern interpretations of the myth of Venus, or rather they are Venus breaking free of her myth. Here we have come a long way from the sixteenth-century Venetian idea of Venus. The female figures are not pantheistic aspirations, nor, like the *Rokeby Venus* of Velázquez (which in other ways is much closer to the *Majas*), a baroque variation on the theme of the real and the imaginary. Goya's *Majas* are painted straight from life. Goya's excursions into religious painting, up to the time of the decoration of San Antón de la Florida, (*pl 52*) had been for the most part conventional. However in the frescoes in San Antón a secular spirit prevails, and the crowd which gathers to watch the miracle, which itself does not have anything supernatural about it, appears to be drawn from far and wide. Religious feeling for once breaks away from the supernatural. This is one of Goya's most revolutionary paintings. It is, in Malraux's words, a painting which illustrates a feeling which had been shared by many of the greatest painters, but which nobody had dared to express: the superiority of the direct statement over symbolic representation; the right of the painter to draw and paint, not in order to create an illusion, nor in order to describe a scene, but in order to express himself.

Goya's religious expression is on a plane apart from that of his predecessors, and this is one of the pointers to his modernity. He places man face to face with himself and his own isolation, rather than relating him to a supernatural guide and consoler, an abstract arbiter of good and evil, possible and impossible. Goya gives man his responsibility

and makes him discover himself by bringing him into contact with the reality with which he may be identified. So ' where Goya portrayed Christ and his sufferings, where he depicted heroism and martyrdom for faith in his unique way, in the *3 May 1808* (*pls 66-7*), Goya's... religion was that of independence, liberty and humanity ' (L. Venturi).

Goya's activity during the last period of his life was largely devoted to works of imagination and to the consolidation of his total freedom of invention, emotion and expression. In this last period we find him turning more to landscape, which had never interested him before; his investigations of the countryside were not of a naturalistic nature; by this time Goya's universe was transfigured, each object merging into the next by a kind of cosmic osmosis, and now even his technique changed. He began to use a specially designed spatula, made from a reed opened out at the bottom which produced a much wider band of colour and far more brilliant images. In the *Colossus* (*pl 63*) and the *City on a Rock*, the landscape is laid out in a way that defies any of the traditional laws of perspective; it becomes a sort of emotional battlefield where fantastic, distorted images sport and play. For the decoration of La Quinta del Sordo Goya stuck entirely to his own idiom. Demons, sorcerers, the supernatural and the mysterious are all entangled in the interpretation of each subject. ' Goya ...comes close to a comic absolute; his view of everything is wildly fantastic, or maybe when he casts his eye on a thing it is turned into something which by its very nature is wildly fantastic ' (Baudelaire). Goya continues to present us with images, though he rejects the traditional aspect of things and concentrates on their symbolical aspect. He rejects colour, light, drawing and plastic modelling; he rejects space and time – the more violent the scene, the more conventions he will reject. His progress towards total self-expression in art can be traced through his graphic works, in the engravings and the drawings. The freedom which graphic work offered led him to try out new techniques and further flights of fancy. His insistence on the truth led him to tear things to pieces to find out what lay behind their smiling exteriors. This also brought him to the use

of caricature, caricature in its real sense of exaggerated portrait. By accentuating certain features he makes his moral immediately apprehensible; physical shape is used solely as a means of conveying his interior vision, and he distorts freely to this end. Graphic work, even more than painting, allowed Goya a natural and personal mode of expression with which to jot down his impressions, his passions and feelings in a kind of private journal. The *Disasters of War,* the *Proverbs* and the *Tauromaquía,* the *Caprichos* painted after Goya's illness, and the so called 'black paintings' in the Quinta del Sordo give us a clear view of Goya's contemporaneity; they bring us forward to Daumier and to the threshold of expressionism with their undogmatic but violent expression. These are bald statements, stripped of the conventional attributes of art; form, colour, drawing, light, perspective are dispensed with in the name of freedom. The importance of his message can be seen all the more clearly if we remember that Goya was a contemporary of David, another artist who brought politics back into painting, but who in his pursuit of a classical ideal managed to shut out life, communication and human nature from his art.

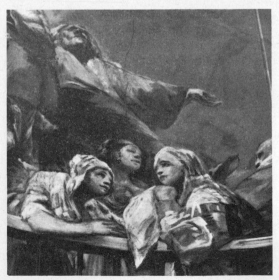

The Miracle of St Anthony, detail (see note to pl. 52 on p. 35)

Goya and the Critics

Goya was either tremendously admired or completely ig-
nored by his contemporaries. His was a very definite person-
ality, and it made a violent impression on people, at times
arousing enthusiasm and at others anger or jealousy. His
contemporaries, even those who admired him, contributed
little critical comment. In the *Diccionario historico de los
mas ilustres profesores de la Bellas Artes en España* by
Céan Bermudez, published by the Academy, there is no
mention of Goya; the book is dated 1800. There is an
important contribution by a Spanish contemporary in a
biograpy complied by Carderera in 1835, with notes contrib-
uted by Goya's son. The later work of Zapater y Goméz
(*Goya, Noticias biográficas,* Saragossa 1868) is a useful source.
The real discovery of Goya took place during the second
half of the nineteenth century, and was mainly the work of
the French. Baudelaire was the first to estimate the worth
of Goya in his critical consideration of the caricatures: he
saw these as an enquiry into the behaviour of mankind in
general. Baudelaire wrote about Goya: ' In him we find love
of the inexpressible, a feeling for the most violent contrasts,
for terrors shared by everybody and for faces which life has
moulded into a thousand weird animal shapes. Goya's great
strength lies in his having created credible monsters. His
monsters are alive, they strike a chord. Nobody more than
he has dared to make the absurd possible. All his distor-
tions, his bestial and diabolical faces, are filled with human-
ity. Even from the point of view of natural history it
would be difficult to find grounds for complaint, so carefully
constructed are the different parts of his inventions. In
short the dividing line, the razor edge between the real
and the imaginary completely evades detection; it is an ill-
defined, vague distinction which even the subtlest, most
careful analyst could not point to, and Goya's art, while
seeming so natural, transcends such distinctions ' (' Quelques
caricaturistes étrangers ' in *Le Présent,* Paris 15 October
1857; reprinted in *Curiosités esthétiques,* Paris 1880).

It almost goes without saying that Delacroix shared Baudelaire's enthusiasm for Goya. For Delacroix the classical idea only made sense if it were brought alive with details from everyday life. Théophile Gautier, in the journals of his *Voyage en Espagne* (Paris 1845, pp 121-37) of all the Spanish painters discusses only Goya in any depth: 'He intended only to paint what was in his imagination, but he has given us a total portrait of old Spain as she then was, while seeking to express his support of the new ideas '. In 1858 L. Matheron, in *Goya* (dedicated to Delacroix), observed that ' his humour is a weapon which he uses to attack everything that to him smacks of control or discipline'. Matheron's analysis of Goya's art it not always so accurate. Also very representative of its period is Yriarte's study, published in 1867; he, like many others, pays too much attention to the polemical and satirical side of Goya and too little to his art; his work contained one of the earliest catalogues of Goya's paintings. Goya's graphic work was very much admired by the Goncourts. Followers of naturalism in the late nineteenth century saw Goya as a kind of symbol, and so did the symbolists. Cruzada Villaamil, Viñaza (1887) and Lefort (catalogue of the graphic work of Goya, 1887) have the merit of having pioneered scholarly studies which have led to a total view of the works of Goya. In this century modern taste in painting has opened the way to a true understanding of Goya. The artist has emerged as someone who was years ahead of his time in his choice of subjects and in his use of social satire. The beginning of the twentieth century saw the beginning of specialized research into single aspects of Goya's work, character and life. Two of the first people to take part in this were Tormo (1902) and Von Loga (1903); then came Hofmann's studies of the etchings (1907), and later Delteil's catalogue (1922). Also worthy of note are the studies of Goya's drawings by D'Acchiardi, Boix and Sánchez Cantón. To Sánchez Cantón we owe one of the first critical monographs and a fine reconstruction of Goya's life (1930); another early monograph is by Mayer (1923).

An opportunity for further studies, and for showing Goya's paintings, was the centenary of his death in 1928. The

studies of Desparmet-Fitzgerald (1928-1950) are valuable, if not absolutely accurate. Nearer our time a variety of interesting theories has been put forward by André Malraux, Ortega y Gasset, López Rey and L. Venturi. Essays on Goya now exist in their hundreds, particularly from the pens of his compatriots. Amongst these the most noteworthy are by Lafuente Ferrari, Sánchez Cantón, Camón Aznár and V. de Sambricio. Non-Spanish studies include essays by J. Lassaigne (Paris 1948), A. Vallentin (Paris 1951) and C. Sterling and R. Huyghe.

In conclusion, here is a short bibliography: F. J. Sánchez Cantón, *Museo del Prado: Goya, II: Ochenta y cuatro dibujos inéditos,* Madrid 1941; J. Lopez-Rey, ' A Contribution to the Artist's life: Goya and the world around him ', in *Gazette des Beaux-Arts,* pp. 129-50, 1945; L. Venturi, *Pittori moderni,* Florence 1946; V. de Sambricio, *Tapices de Goya,* Madrid 1946-8; E. Lafuente Ferrari, '*El Dos de Majo*' y '*Los fusilamientos*', Barcelona 1946; F. J. Sánchez Cantón, *Los Capricios de Goya y sus dibujos preparatorios,* Barcelona 1949; A. Malraux, *Saturne: essai sur Goya,* Paris 1950; J. Ortega y Gasset, *Papeles sobre Velázquez y Goya,* Madrid 1959; J. Camón Aznár, ' La estética de Goya en los Disparates ', in *Revista de Ideas Estéticas,* no 35, 1951; J. López-Rey, *Goya's Caprichos,* Princeton 1953; F. J. Sánchez Cantón, *Los Dibujos de F. de Goya,* Madrid 1954; E. Lafuente Ferrari, *Goya: his complete etchings, aquatints and lithographs,* New York and London 1963.

Notes on the Plates

The Virgin of El Pilar, c. 1763 (ill. on p. 17). Reliquary, formerly at Fuendetodos. Goya's first major work, destroyed in 1936.

1 Self-portrait, 1817-19. Madrid, Prado, 46 × 35 cm. The trick, borrowed from Rembrandt, of making the face emerge from deep shadow by play with the lighting accentuates the expression of the face but almost does away with any detailed descriptive painting.

2-3 The Sunshade, 1777. Madrid, Prado. Cartoon for a tapestry made at the Royal Factory at Santa Barbara expressly for the dining room of El Pardo. Like all Goya's cartoons it is painted in oils on canvas, and is not planned like an ordinary sketch.

Boys blowing up a bladder, 1777 (ill. on p. 15). Madrid, Prado, 119 × 122 cm. (detail) Cartoon for tapestry above door in El Pardo.

4-5 The Crockery Seller, 1779. Madrid, Prado. Part of a later series of cartoons for the Royal Factory. Made for the Princes' Bedroom in El Pardo.

6 Fair in Madrid, 1779. Madrid, Prado, Cartoon for tapestry, intended like *The Crockery Seller* (pls. 4-5) for the Princes' Bedroom at Aranjuez. Both cartoons contain a strong element of social criticism.

7-8 The Washerwomen, 1780. Madrid, Prado. Cartoon for tapestry, delivered 24 January 1780; made for the Princes' Bedroom in El Pardo. The bright realistic colours emphasize the poetry of the landscape; the painting is more a pastoral than a scene from everyday life.

9-11 The Blind Guitarist, 1778. Madrid, Prado. Cartoon for tapestry, for the Princes' Bedroom in El Pardo. The design is cleverly worked out and shows Goya's growing freedom, in particular the face of the blind man. The significance of the scene is concentrated in the study of the face.

12 Crucifixion, 1780. Madrid, Prado. Painted for the competition for admission to the Academy of San Fernando, Madrid; Goya evidently wanted to adhere to academic taste, and in this painting he shows an unusual interest in the modelling of the figure. The face wears a tragic expression such as Bayeu would have approved (there is a drawing of Christ in the Prado by Mengs, which was clearly the model for Goya's painting), but it is broadened in a typical way by quick brushstrokes, accentuating the contrast of light and shade. The picture remains a work designed for an academic public.

13-15 The Virgin, Queen of Martyrs, 1780-1. Fresco, painted in a dome in the Cathedral of El Pilar, Saragossa. Goya worked on it from October 1780 to June 1781. The first sketches, painted very realistically and with a very loose plan and technique, caused a rift between Goya and his brother-in-law, who was directing the decoration of the church. In spite of the modifications Goya was forced to make, the painting is one of the first examples of Goya's mature technique; extremely imaginative and sketchy, with figures expressively distorted. The single parts of the whole, which are painted very realistically, seem to have come a long way from the traditional baroque plan on which the whole is based, yet the result is harmonious.

16-17 Portrait of the Count of Floriblanca, 1783. Madrid, Banco Urquijo. Oil on canvas. 262 × 166 cm. Obviously painted to flatter the powerful statesman, it is one of Goya's least successful portraits; it shows the artist himself ill at ease in the face of officialdom.

18-19. Winter, 1786. Madrid, Prado. Oil on canvas. 275 × 293 cm. Cartoon for a tapestry, painted for El Pardo towards the end of 1786. There is a less inhibited sketch (32 × 33 cm.) in the Silbermann collection, New York.

20 The Vintage, 1786. Madrid, Prado. Oil on canvas. 275 × 190 cm. Cartoon painted in the autumn of 1786, when Goya had become Royal Painter. Painted in a relaxed mood (Goya had by this time won a certain measure of fame) it shows imaginative progress, particularly in the liveliness of the figures and the painting of the background.

21-3 Summer, 1786. Madrid, Prado. Oil on canvas. 276 × 641 cm. Also known as *The Threshing floor*, it was painted in the autumn of 1786. A sketch of the same subject for the Alameda of Osuña is in the Museo Lázaro, Madrid.

24-5 Portrait of the Marquesa de Pontejos, c. 1786. National Gallery, Washington. Oil on canvas. 211 × 126 cm. A most delicate painting, with its pinkish greys and precious fabrics, almost in the style of a tapestry cartoon. This portrait demonstrates Goya's acquaintance with French and English portrait styles, seen however through the conventionality of Mengs.

26 The Wounded Mason, 1786. Madrid, Prado, 268 × 110 cm. Cartoon painted at the end of 1786; another version for the Alameda of Osuña has variations; the treatment of the subject is less conventional.

27. The Tree of Cockayne, 1787. Madrid, collection of the Duke of Montellano. 169 × 89 cm. Its narrative realism and decorative qualities are perfectly balanced; it illustrates Goya's eclecticism and his great vitality.

28. Swing, 1787. Madrid, collection of the Duke of Montellano. 169 × 101 cm. Painted at the same time as the *Tree of Cockayne* and five other works for the Alameda of Osuña; it shows the influence of French taste, particularly of Watteau.

29 The Hermitage of San Isidro on a Feast Day, 1789. Madrid, Prado. 42 × 44 cm. Unfinished cartoon for a tapestry.

30-1 The Field of San Isidro, 1788. Madrid, Prado. 44 × 94 cm. This is the cartoon which was on Goya's mind in a letter written to Zapater on 31 May 1788. In a large landscape, typical of tapestry scenes, Goya paints a traditional scene of Madrid life. He concentrates on capturing the view of Madrid and a *fête galante* in local style, rather than recording the scene with absolute accuracy.

32 The Manikin, 1791. Madrid, Prado. 267 × 160 cm. Tapestry cartoon painted for the Bedroom of the Infante in El Pardo. One of the last cartoons for the Royal Factory. The subject is most gracefully treated and seems almost to hide an allegorical significance. The sad, humiliated puppet has all the attributes of a human being, masked and disguised.

33 Pick-a-back, 1791. Madrid, Prado. 137 × 104 cm. Cartoon for a tapestry designed to go over a doorway. This is one of Goy's last cartoons for the Royal Factory.

34-5 Witches' Sabbath, 1798. Madrid, Museo Lázaro. Oil on canvas, 43 × 40 cm. The characters dancing as if magnetized round the sorcerer are violently distorted.

36-7 The Spell, ? 1798. Madrid, Museo Lázaro. Oil on canvas, 42 × 30 cm. This is usually thought of as one of the small paintings, all showing scenes of witchcraft, bought by the Osuña family in 1798. Some people however place it at an earlier date, about 1793-4, soon after Goya's illness. More than the others in the series it seems to belong to the same date as the *Caprichos* painted in 1799.

38-9 The Burial of the Sardine, ? 1793. Madrid, Academy of San Fernando. Oil on panel, 83 × 62 cm. This work marks a decisive change in Goya's work – both the subject and the technique reflect new freedom. Critics are divided on its date, some putting it at about 1793, others 1800 and other as late as 1808. Stylistic links and the imaginative ' caprice ' subject attach it to the earlier date, in my opinion, immediately after Goya's illness.

40 Procession of Flagellants, c. 1800. Madrid, Academy of San Fernando. Oil on wood, 41 × 72 cm. The same problem is attached to the dating of this painting as for the preceding one. However, its dramatic strength and satirical approach probably mean it belongs to around 1800. Flagellants disappeared completely after an edict from Napoleon in 1799.

41-3 Court of the Inquisition, c. 1800. Madrid, Academy of San Fernando. Oil on panel, 45 × 72 cm. Can be dated with reasonable certainty by means of stylistic analogies. Goya intended a denunciation to be read into his portrayal of this grotesque assembly.

44-5 The Madhouse, c. 1800. Madrid, Academy of San Fernando. Oil on wood, 45 × 72 cm. This also belongs to the preceding group, first attributed to 1793, then postponed to around 1800. It is a work of great maturity. The subject, itself very unusual and difficult, is accentuated by careful distortion of the figures and a strong attention to atmosphere; the architecture and the lighting of the figures give the scene tremendous dramatic power.

46-7 The Bull Ring, c. 1800. Madrid, Academy of San Fernardo. Oil on wood, 45 × 72 cm.

48 Portrait of Francisco Bayeu, 1795. Madrid, Prado. Oil on canvas, 112 × 84 cm. Painted immediately after Bayeu's death. Compared with an earlier portrait, painted in 1786, it shows greater control of materials; an added refinement is the use of contrasting shades of grey.

49 Doña Antonia Maria Gonzaga, Marquesa de Villafranca, before 1800. Madrid, Prado. 87 × 72 cm. Judging by the apparent age of the sitter (b. 1735 – d. 1801) this portrait was painted in the last years of the century. Preserving the dignity of the official portrait, Goya has given us a masterpiece of introspection and naturalness.

50 Self-portrait, 1787-1800. Castres, Musée Goya. 50 × 30 cm. The artist shows himself with spectacles, already in middle age. With rapid strokes he conveys his character most clearly.

51 Portrait of Moratín, c. 1824. Madrid, Academy of San Fernando. Moratín wrote of Goya in 1824: ' Goya is very full of himself; he paints as much as he can and never stops to correct what he has painted '.

52 Dome of San Antón de la Florida, 1798. Madrid. In the biographical notes given by Goya's son to Carderera and in the Archives of the Royal Palace these frescoes are mentioned as having been painted in 1798. In Madrid, in the collection of the Condesa de Villagonzalo, there is a sketch in oils (26 × 38 cm) which gives a rough idea of the subject. Goya found a source in the story of Father Croisset, translated into Spanish and widely known; but Goya's interpretation of the story is absolutely his own. We do not know exactly how long these frescoes took him to paint; documents relating to the hire of a carriage name 120 days, but given Goya's immense speed at fresco painting one imagines that he would not need to spend so long. The results are extraordinary in their modernity, thanks to Goya's sketchy technique and the realism of his figures; both the treatment of his subject and the composition of the frescoes are unconventional. See also ill. on p. 28.

53 Portrait of the actress La Tirana, 1794. Madrid, Academy of San Fernando. 112 × 79 cm. Extraordinary technical virtuosity and directness of approach make the actress seem human without destroying her dignity.

54 Portrait of Ferdinand Guillemardet, 1798. Paris, Louvre. Oil on canvas, 185 × 125 cm. Goya captures the ambitious, self-confident nature of the French ambassador, exaggerated in order to bring out his inordinate vanity. Very lively painting of the jewellery and feathers.

55 Charles IV on Horseback, 1799. Madrid, Prado. Oil on canvas, 305 × 279 cm. Drawings and sketches for this painting still exist.

56-7 The Family of Charles IV, 1800. Madrid, Prado. Oil on canvas, 280 × 336 cm. Painted at Aranjuez in spring 1800, after some preparatory sketches (now in the Prado) which are marvellous portraits in themselves. In plan this is a full dress portrait *par excellence,* but in the study of the individual figures Goya eschews all obsequiousness; his love for detail is apparent.

58 The Maja Clothed, c. 1797-1800. Madrid, Prado. 95 × 190 cm. The history of this painting is exactly the same as the history of the *Maja Nude.*

59-60 The Maja Nude, c. 1797-1800. Madrid, Prado. 95 × 190 cm. Presumably painted in the last two or three years of the century. It provoked curiosity and a certain amount of scandal in its day; Goya's contemporaries guessed that the Duchess of Alba had posed for this picture as she had for other pictures of *Majas.* This was certainly not true, The two paintings, a pair, appear in the inventory of the court favourite, Godoy, as ' Gipsies '. The kind of portraiture invented by Goya here inspired a great deal of French painting in the nineteenth century.

61 Majas Walking, c. 1811. Lille, Musée des Beaux-Arts. Oil on canvas, 181 × 122 cm. Also called *The Note,* this painting is described in the 1812 inventory. The composition recalls an eighteenth-century scene of gallantry, but the psychological analysis of the principal characters, and the realistic painting of the background figures, contrast with this.

62 The Sickness of the Mind, 1799. This an etching from the well-known collection of *Caprichos.* In a letter dated 17 July 1803, Goya presents his work to the King and says: ' My series of *Caprichos* consists of eighty plates etched in *aqua fortis* by my own hand '. The plates are now in the Calcografía Nacional, Madrid.

The Sleep of Reason Brings Forth Monsters (ill. on. p. 37). Ink drawing. A sketch for no. 43 of the *Caprichos* (another, dated 1797, is in the Prado). This is an intermediate stage in the development of the work; the images have already been transformed into ' monsters '.

63 Colossus, ? 1808-12. Madrid, Prado. Oil on canvas, 116 × 105 cm. This picture, subtitled *Panic*, clearly alludes to the fear generated by war, personified in the huge figure of the Colossus.

This picture is identifiable as one of the works mentioned in the inventory of 1812; therefore its date is probably somewhere between 1808, the year of the beginning of the war, and 1812.

64-5 2 May 1808, 1814. Madrid, Prado. Oil on canvas, 266 × 345 cm. Commissioned by the king for a large fee to *perpetuar por medio del pincel la más notables y heroicas acciones... de nostra gloriosa insurrección contra el tiranno de Europa.* Two sketches of

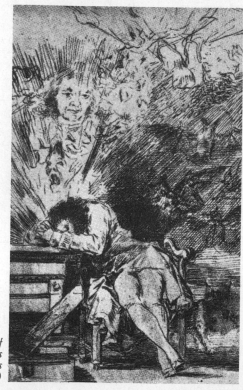

The Sleep of Reason Brings Forth Monsters (see note on p. 36)

37

the painting exist, the second of which is the more like the finished work. Goya obtains his effect by painting a very crowded scene, in a great variety of colours. The figures are rhythmically linked. This picture illustrates why Delacroix liked Goya's work so much.

66-7 3 May 1808, 1814. Madrid, Prado. Oil on canvas, 266 × 345 cm. Twin of the preceding canvas, its dramatic effect is even greater. This is achieved by a simplification of the composition and shapes; Goya's horror of brutality is immediately apprehensible in his distortion of the figures. His protest here is of almost religious intensity. The dark background seems to be part of the drama as well. The white-shirted figure of the victim in the centre forms the gravitational centre for both the stereotyped soldiers and the carefully characterized victims.

68 The Last Communion of St Joseph Calasanzio, 1819. Madrid, Escuelas Pías de San Antón. Oil on canvas, 250 × 180 cm. Painted between May and August 1819. It is one of the last works of Goya's religious period.

69 The Agony in the Garden, 1819. Madrid, Escuelas Pías de San Antón. Oil on canvas, 47 × 35 cm. This is an example of Goya's non-conformism and also of his ability to express religious sentiment in human terms. Christ, painted with a few strong brushstrokes, presents all the drama of a victim of human misfortune.

70-7 La Quinta del Sordo, 1820-2. Madrid, Prado. Oil on plaster, detached and attached to canvas. The decoration of Goya's country house, which he acquired in 1819, was undertaken during the years 1820-2, and the paintings are now known as the 'black paintings'. They are the climax of Goya's imagination and fantasy; his subjects are completely transformed through total distortion of the figures and the almost total abolition of colour. Amongst the fourteen paintings which are included in the series are: *Two Old Women Eating Soup* (53 × 85 cm. *pls* 76-7); *The Pilgrimage of San Isidro* (*pls* 71-73); *The Brawl* (*pl* 74); *The Witches' Sabbath* (145 × 438 cm., *pls* 70, 72); *The Fantastic Vision* (123 × 265 cm. *pl* 75). The choice of subjects does not present any narrative sequence. Certain themes are used several times, such as witchcraft and the scenes of San Isidro. Goya's unity lies in his consistent presentation of human beings who have become so grotesque as to be sublime; Baudelaire remarked this in his analysis of the *Caprichos*.

Saturn devouring one of his children 1820-2, (ill. on. p. 39) Madrid, Prado. Oil on plaster, detached and attached to canvas 146 × 83 cm. (detail).

78 The Ascent of a Montgolfière, 1818-9. Agen, Musée. The subject of a balloon ascent is most original, and Goya treats it without any respect for conventional illustration.

79 The Milkmaid of Bordeaux, 1826-7. Madrid, Prado. 75 × 67 cm. This is Goya's penultimate painting, done in Bordeaux. Although the psychological realism and the broad construction of the work are typical of Goya, the lyrical colours are quite new; the melancholy and contemplative face of the girl reflects the temperament of Goya in the last years of his life.

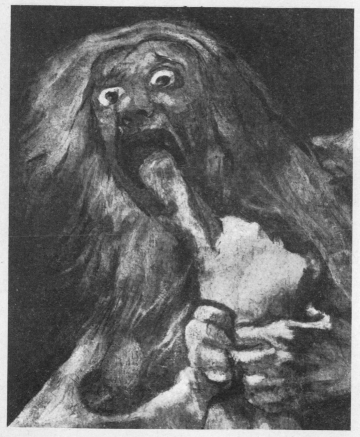

Saturn devouring one of his children (see note on p. 38)

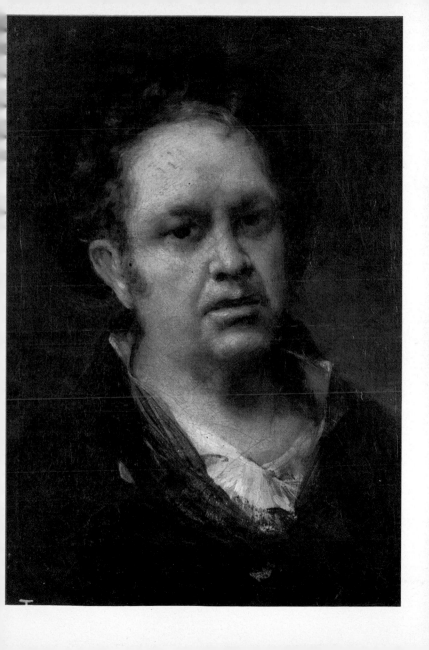

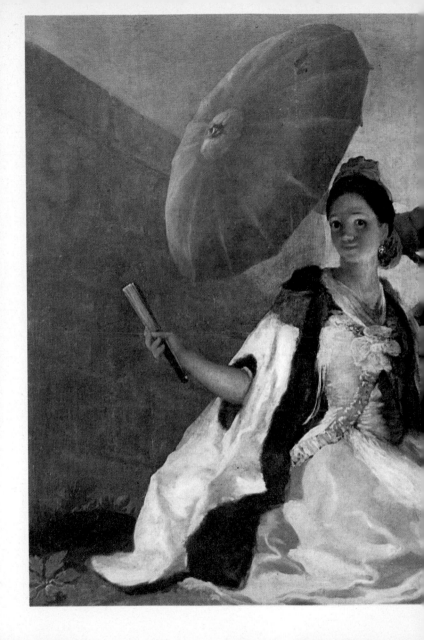

3

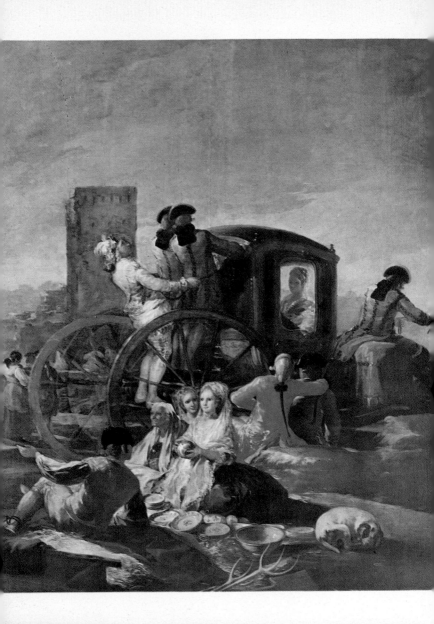

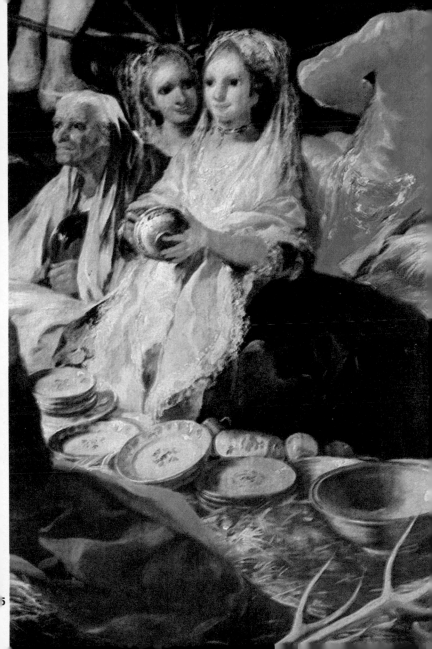

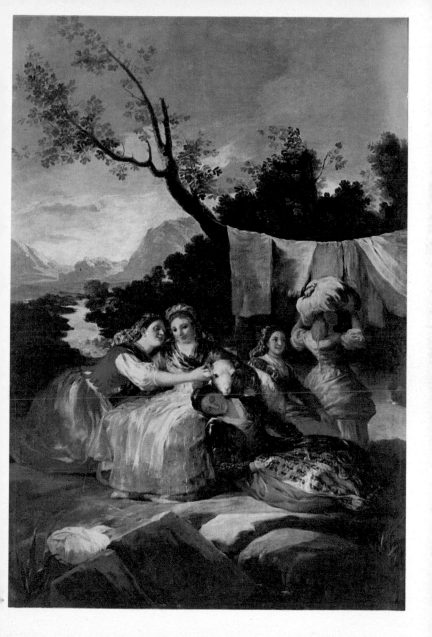

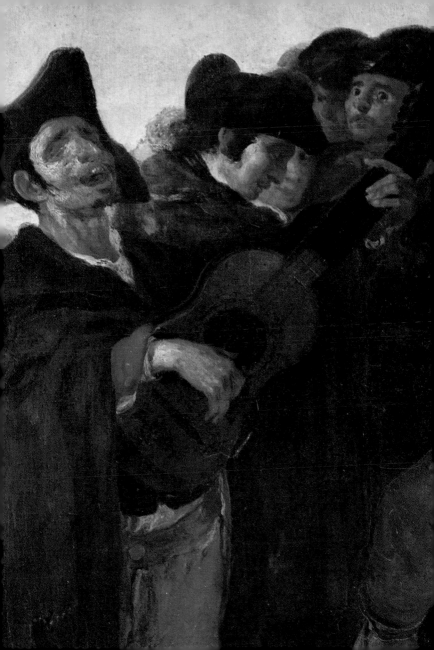

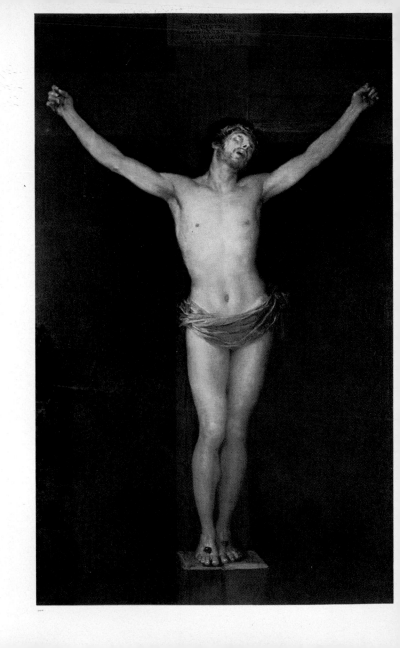

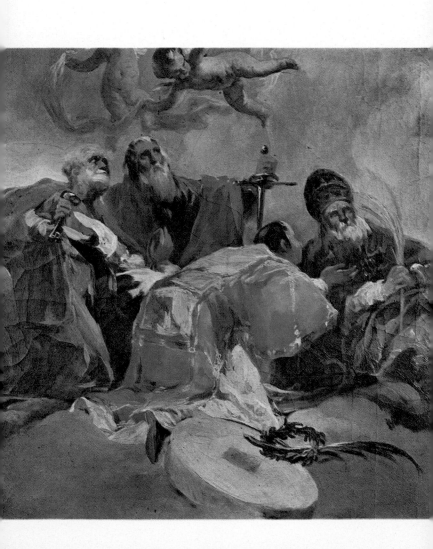

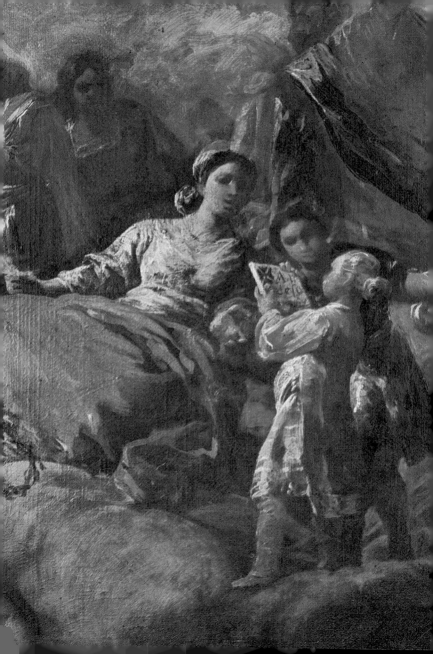

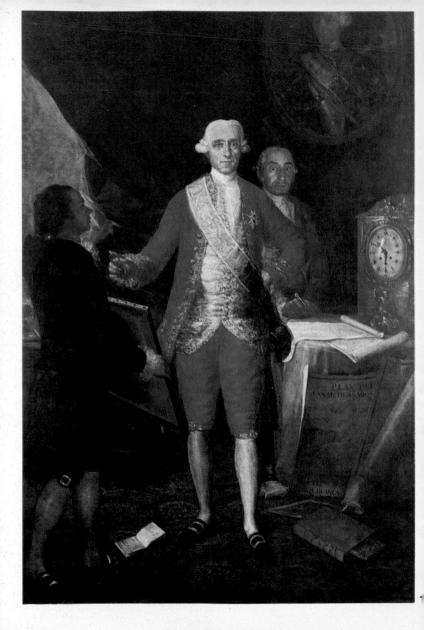

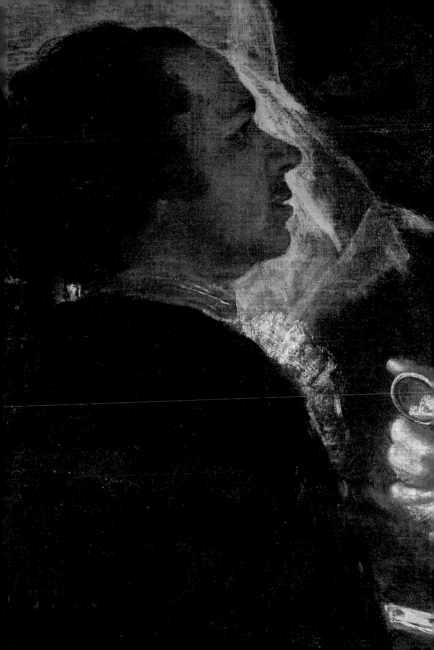

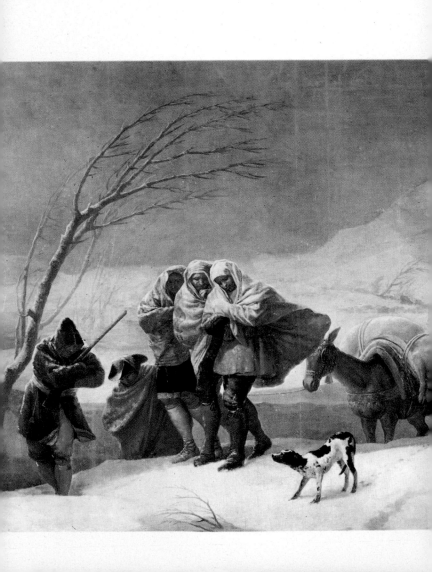

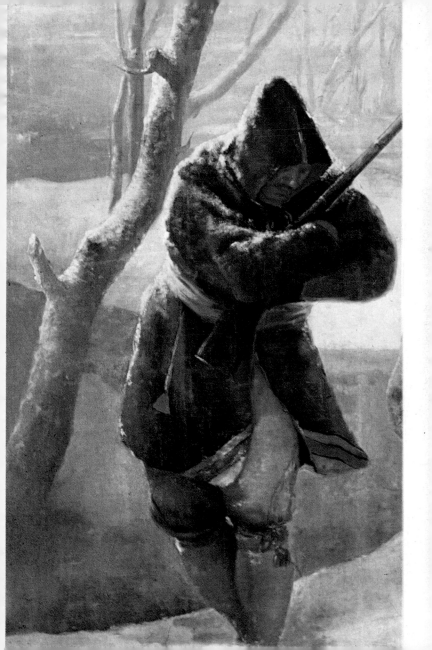

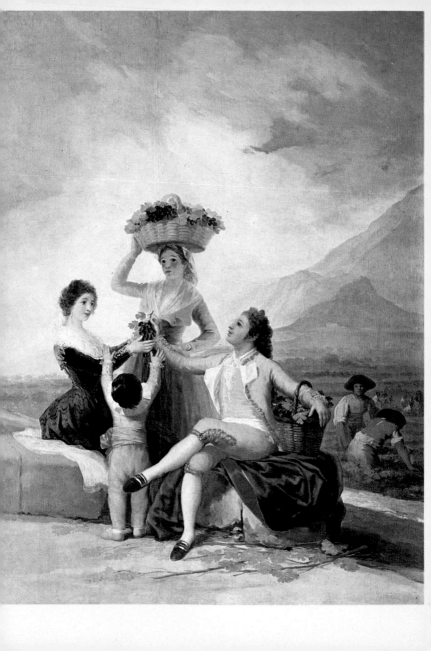

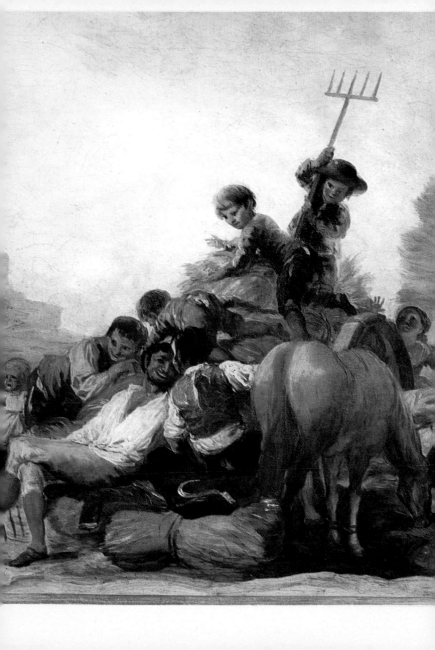

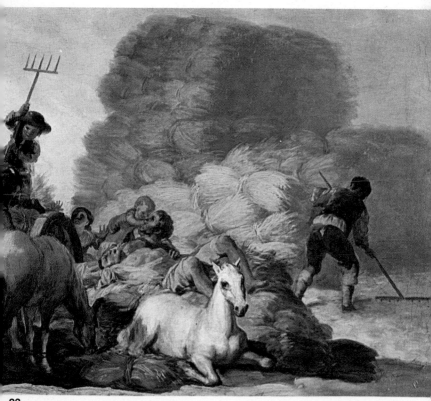

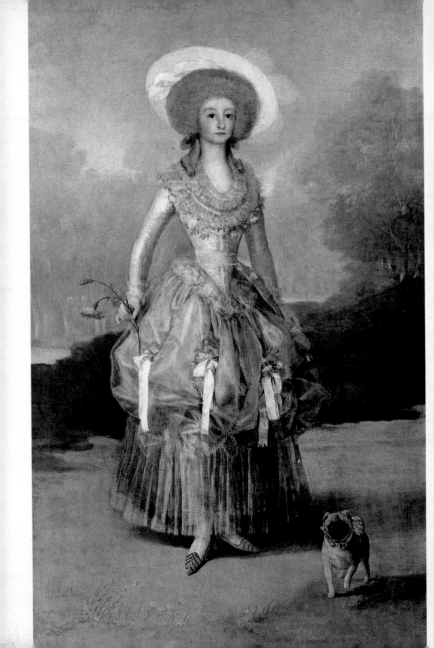

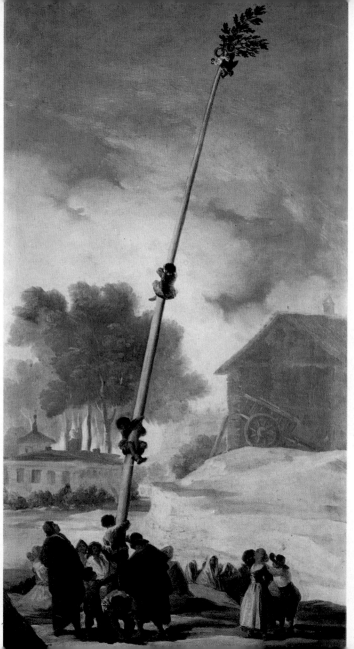

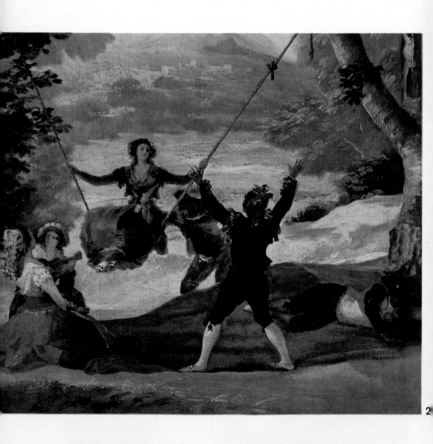

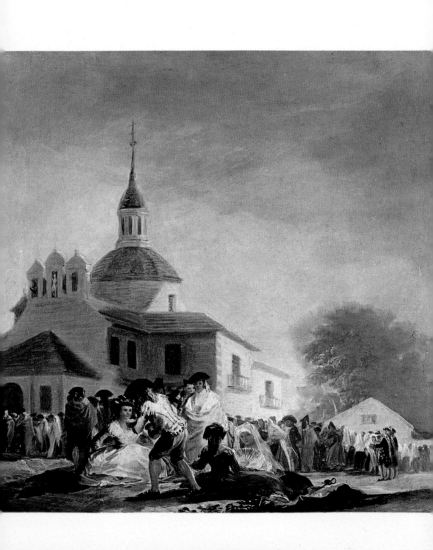

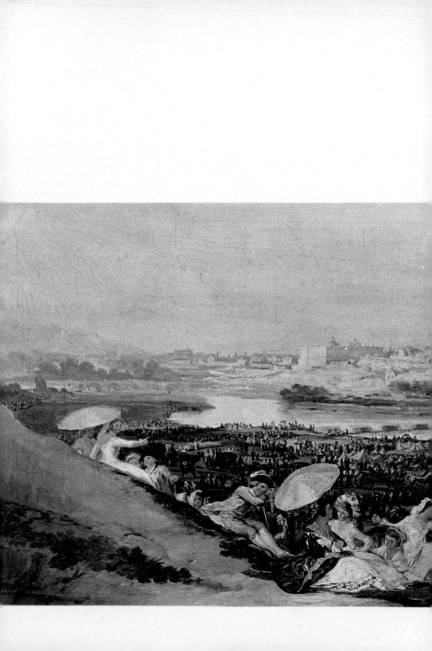

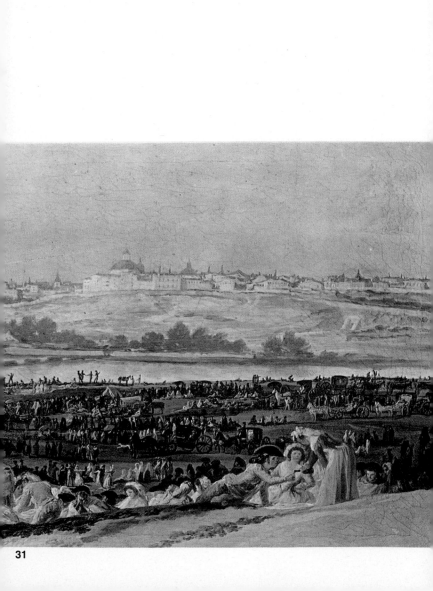

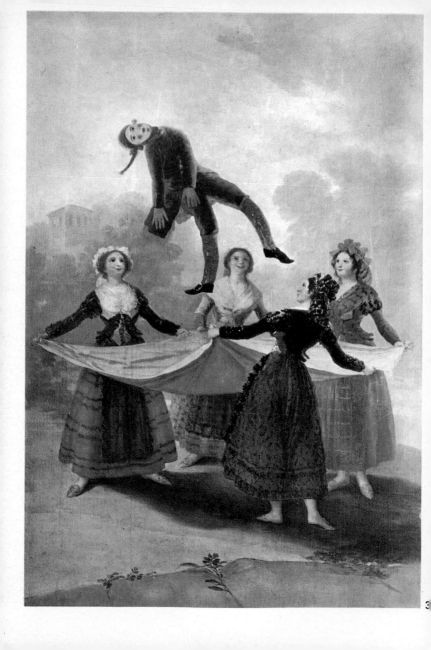

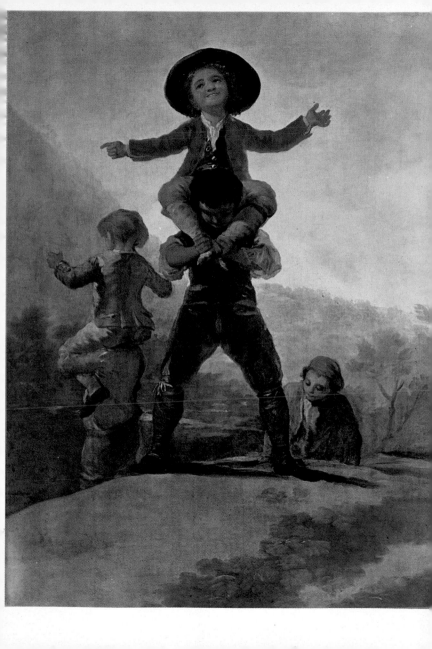

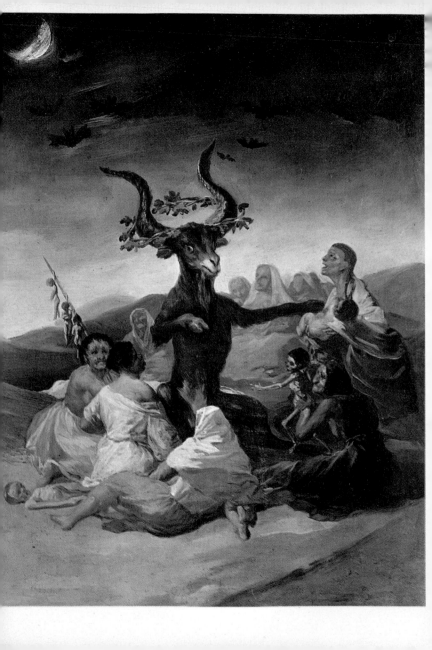

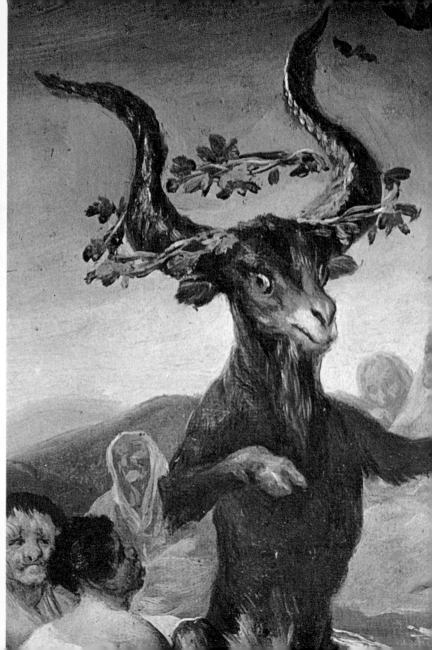

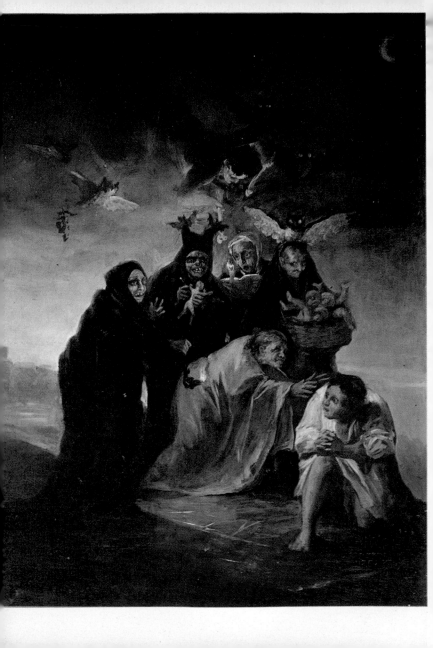

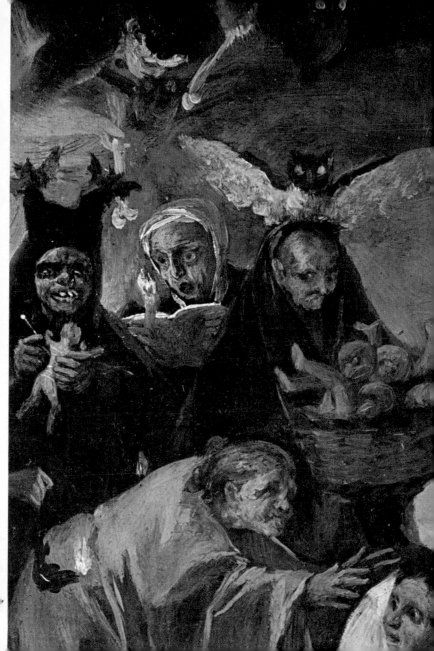

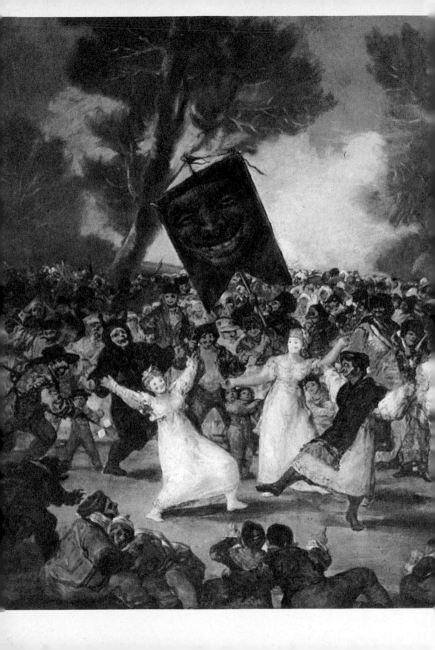

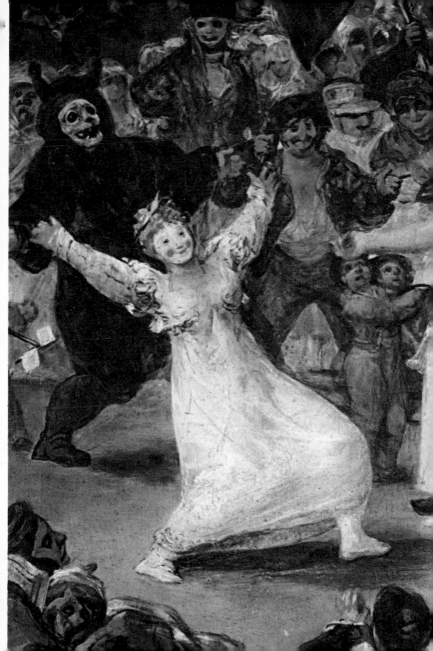

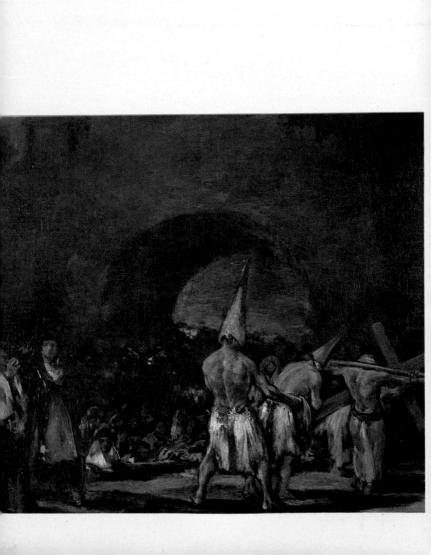

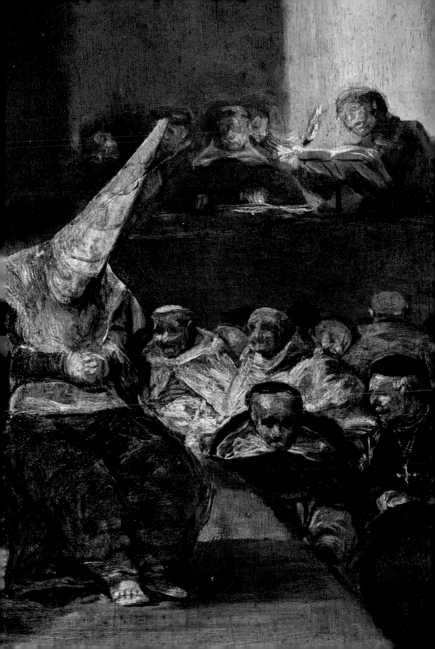

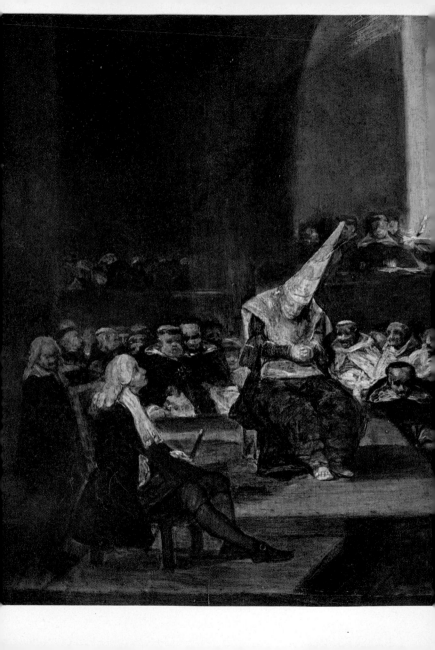

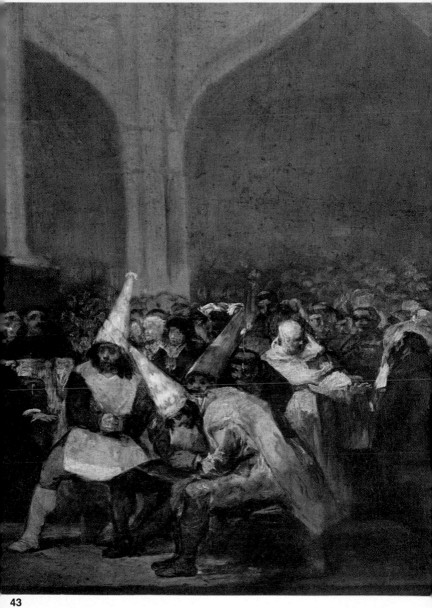

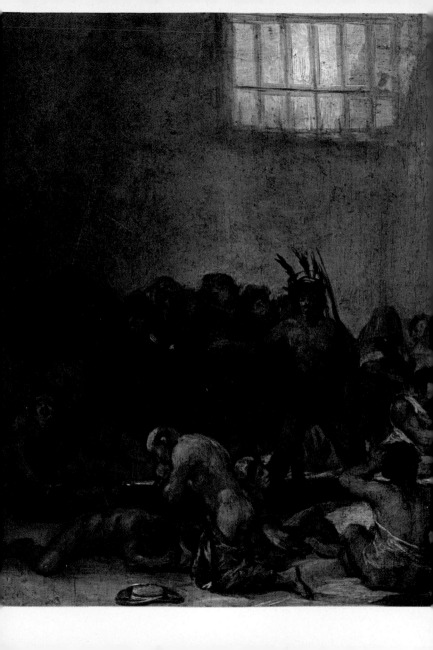

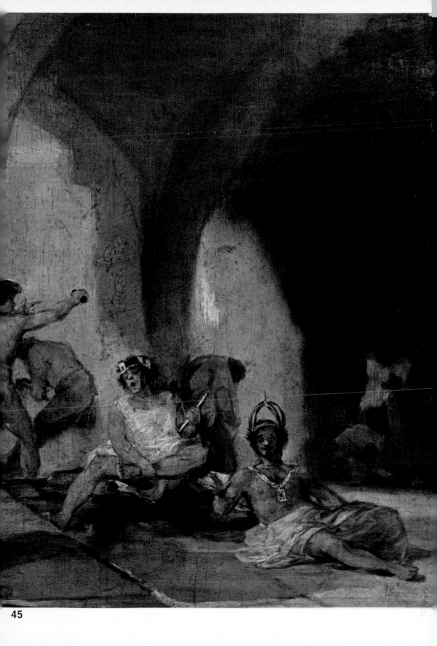

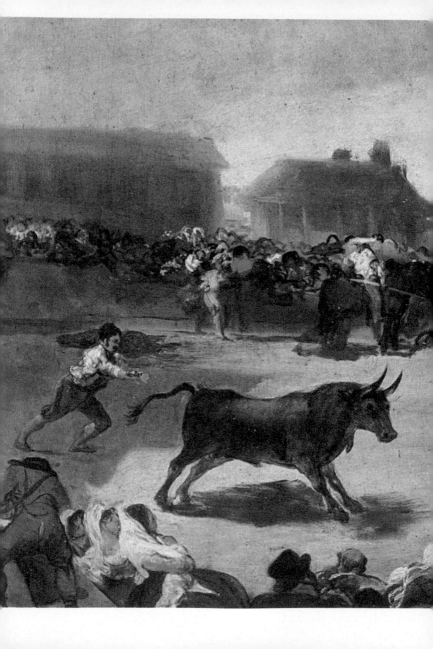

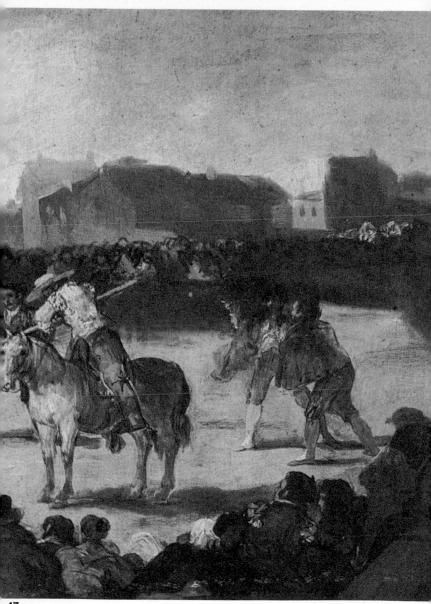

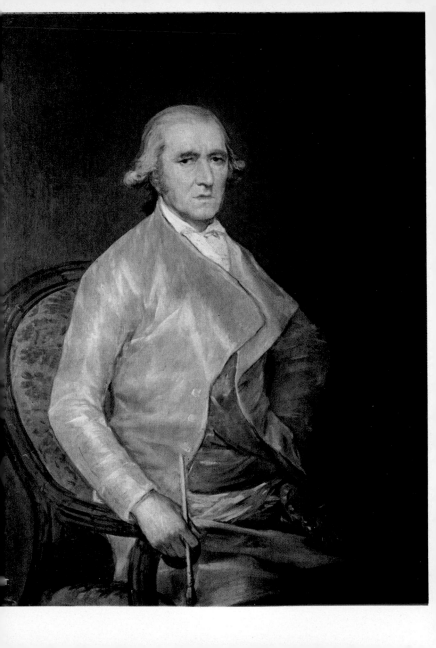

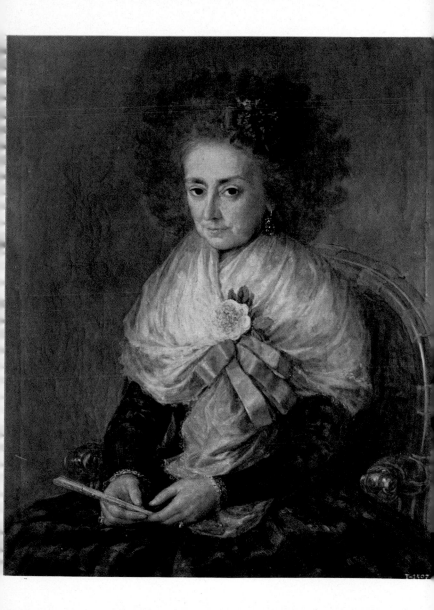

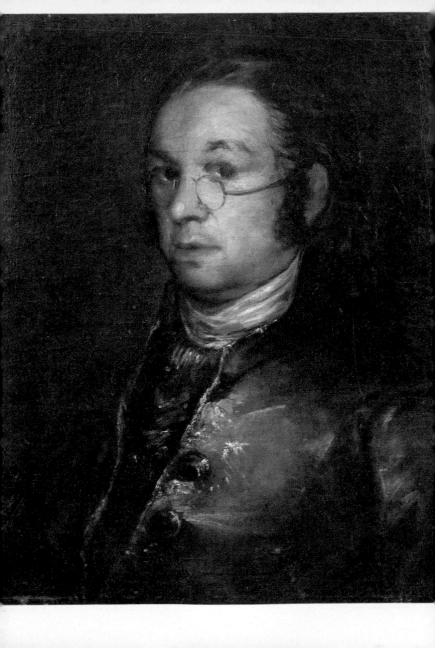

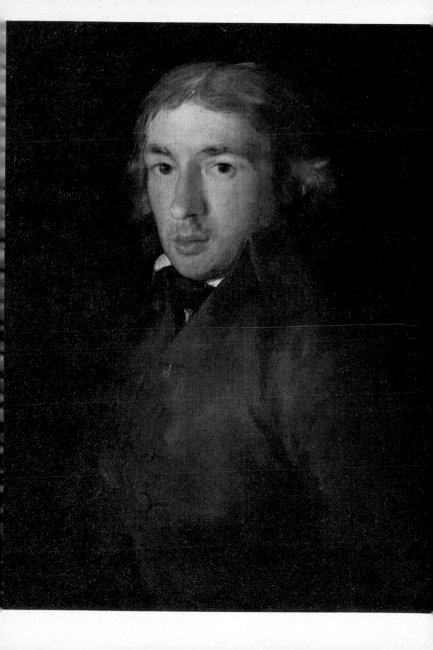

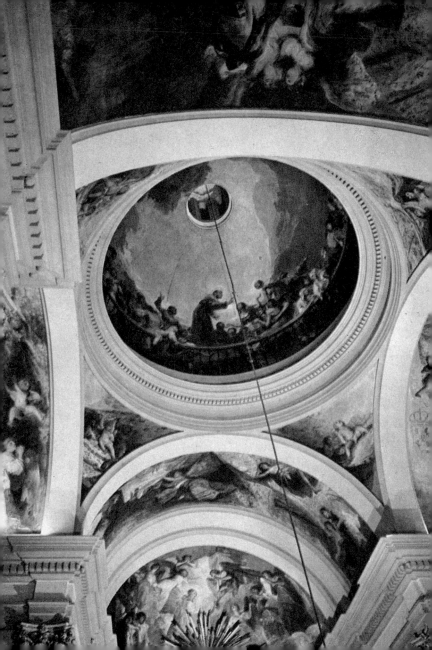

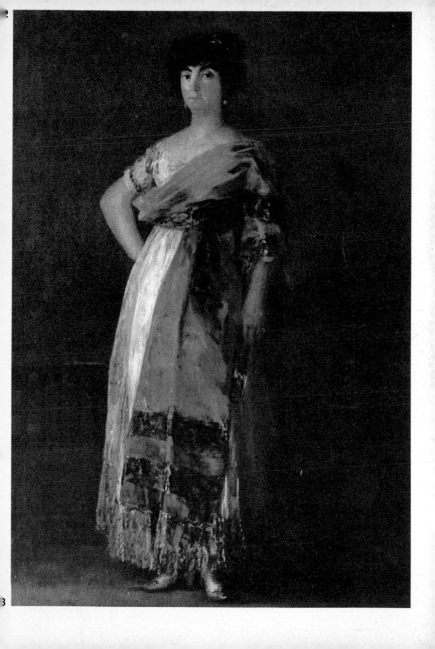

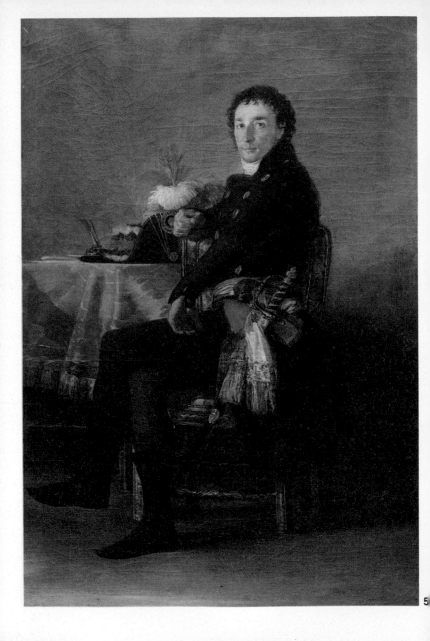

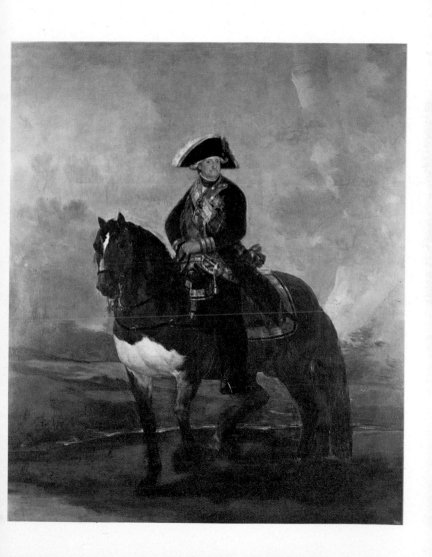

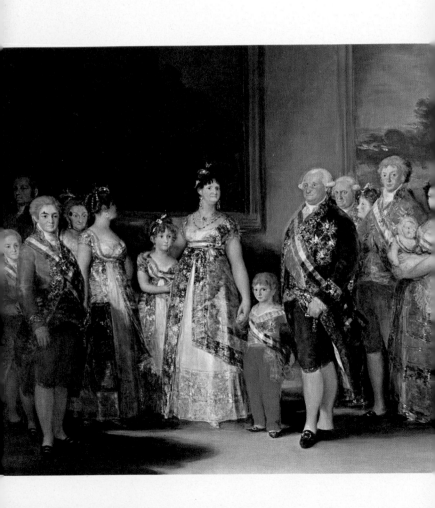

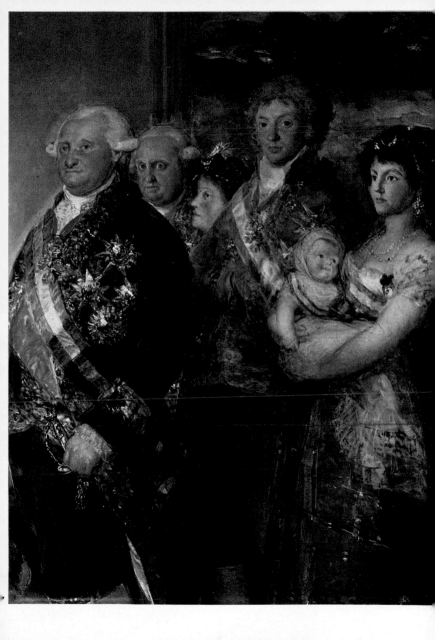

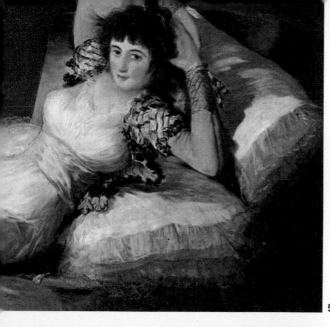

58

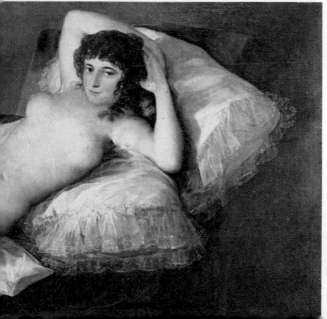

59

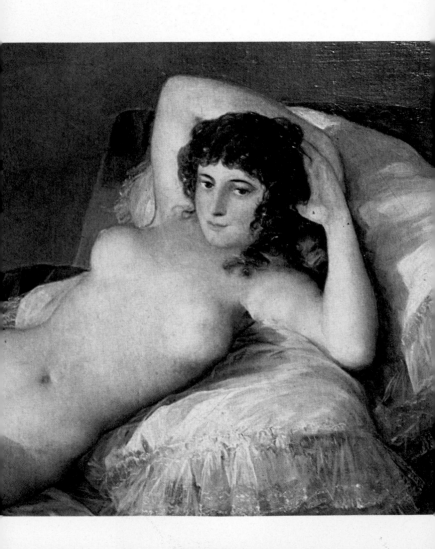

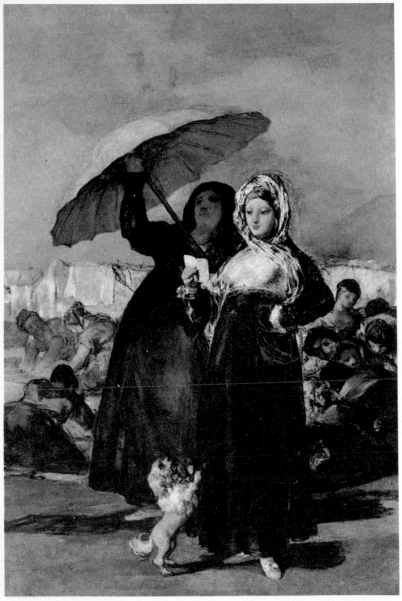

1

La enfermedad de la razon

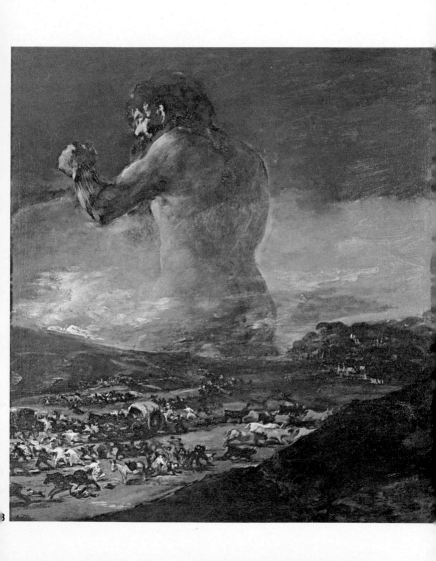

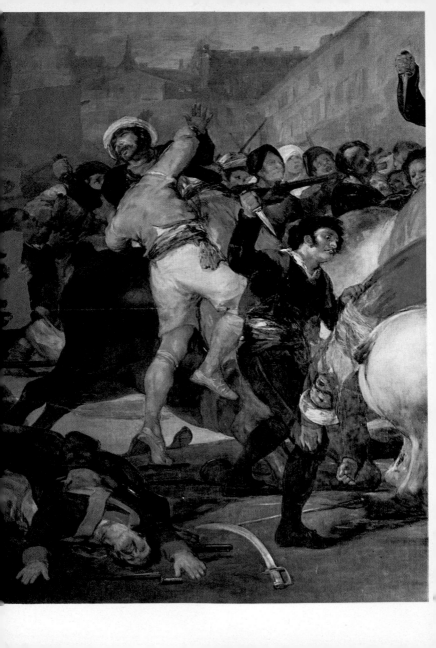

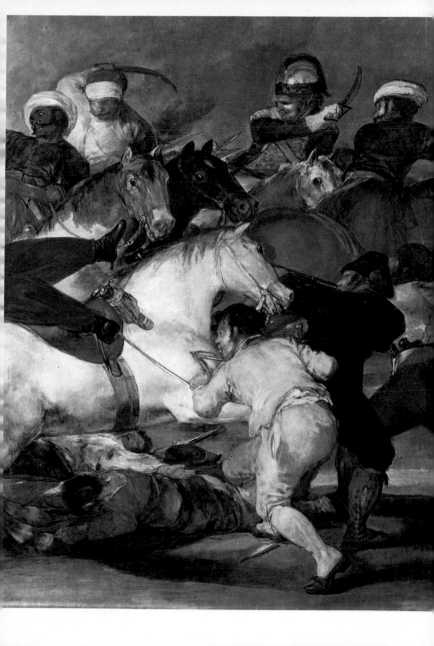

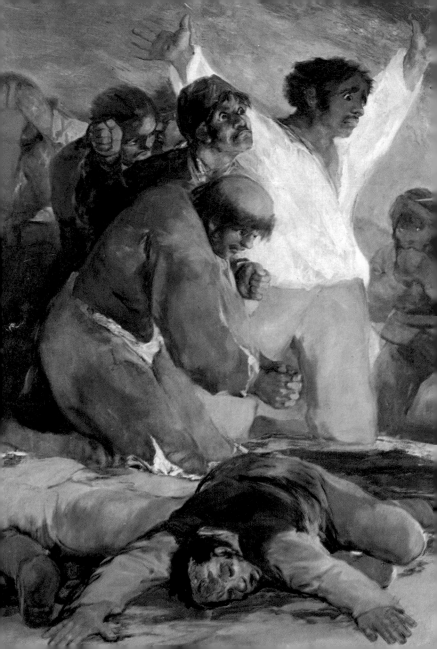

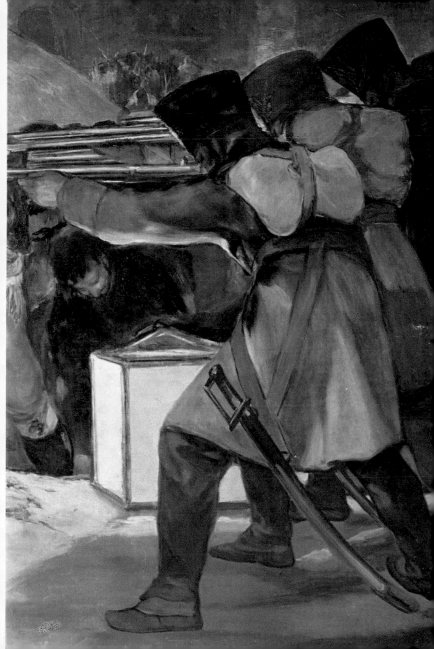

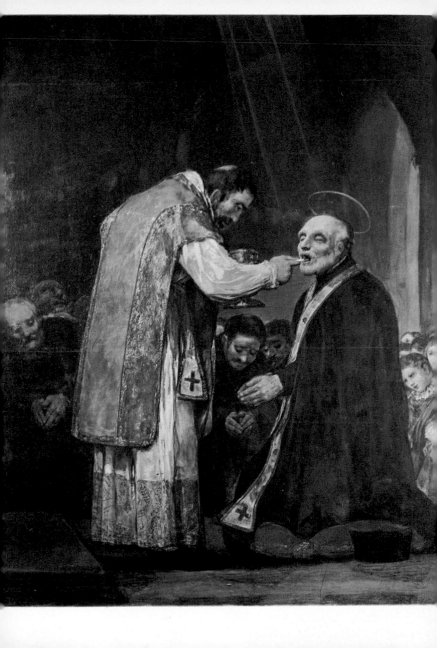

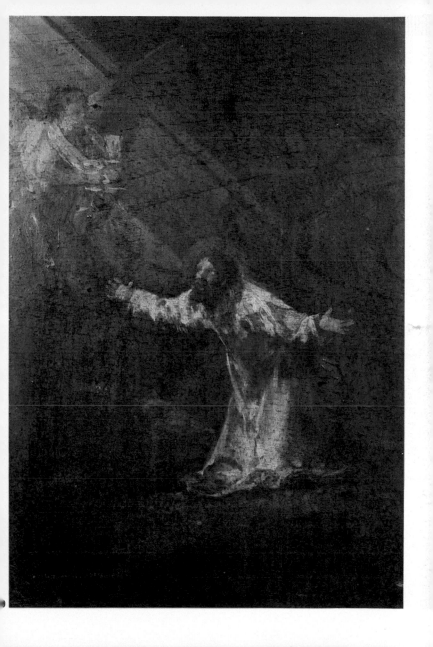

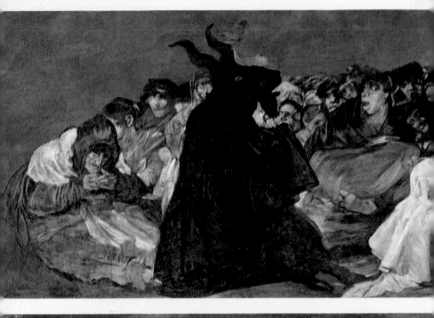

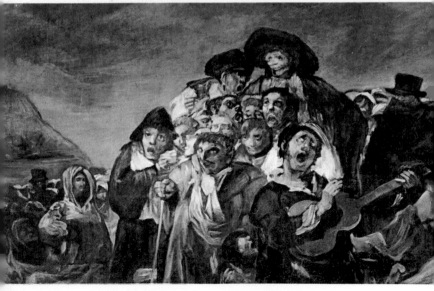

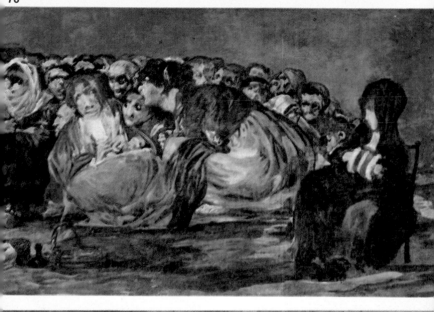

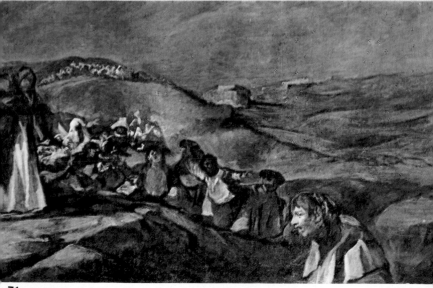

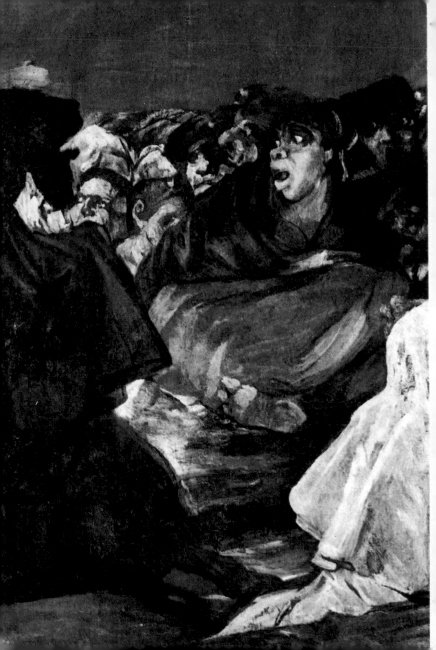

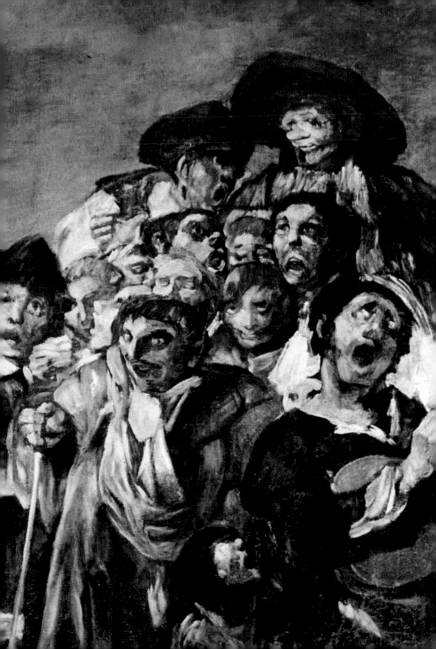

74

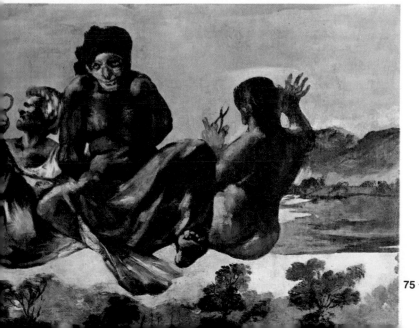

75

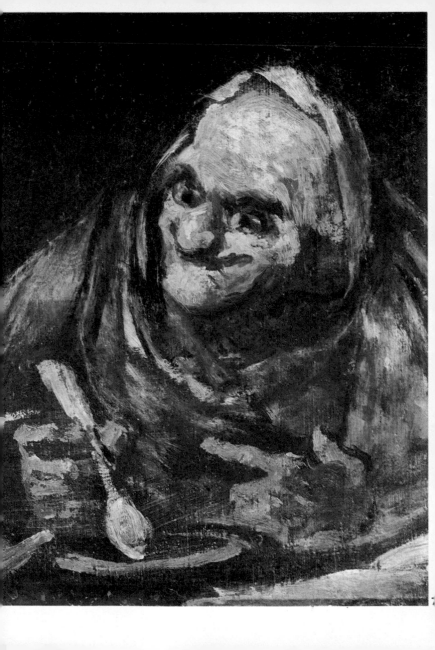

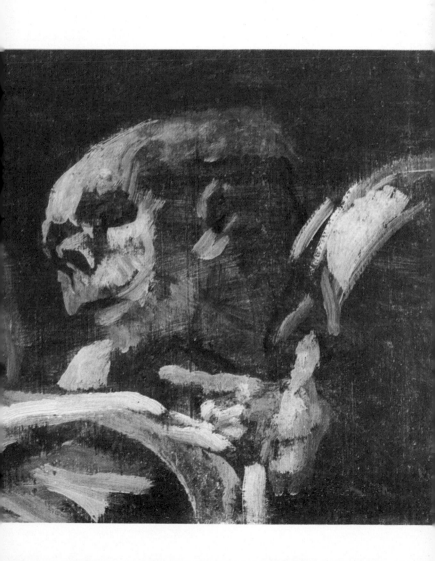

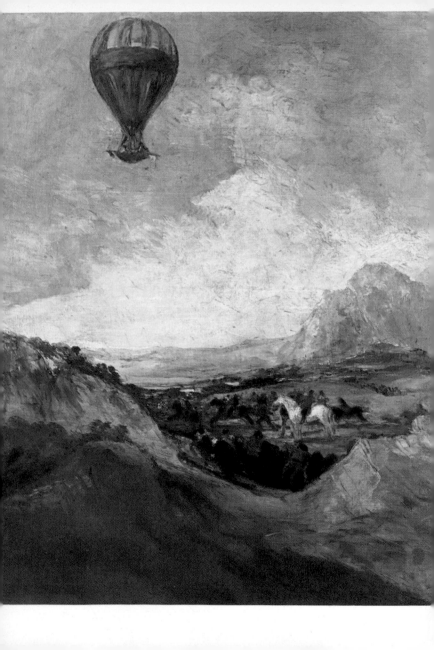

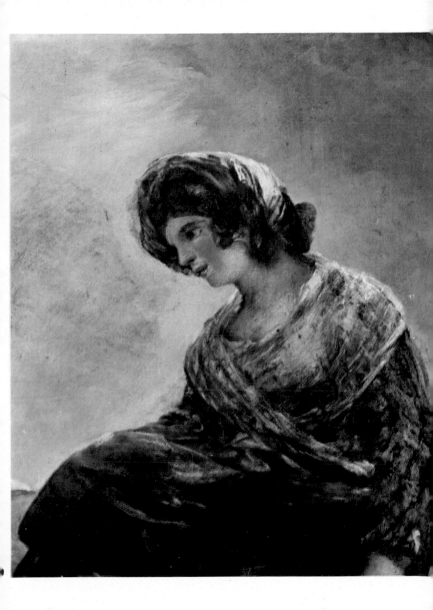